COLLECTING
AND
CARE
OF
FINE ART

An Introduction to Purchasing, Investing,

Evaluating, Restoring, and More

CARL DAVID
Foreword by
RICHARD J. BOYLE

Skyhorse Publishing

Skyhorse Publishing books may be purchased in bulk at special discounts for sales promotion, corporate gifts, fund-raising, or educational purposes. Special editions can also be created to specifications. For details, contact the Special Sales Department, Skyhorse Publishing, 307 West 36th Street, 11th Floor, New York, NY 10018 or info@skyhorsepublishing.com.

Skyhorse® and Skyhorse Publishing® are registered trademarks of Skyhorse Publishing, Inc.®, a Delaware corporation.

Visit our website at www.skyhorsepublishing.com.

10 9 8 7 6 5 4 3 2 1

Library of Congress Cataloging-in-Publication Data is available on file.

Cover design by Rain Saukas

ISBN: 978-1-63450-245-0
Ebook ISBN: 978-1-63450-885-8

Printed in the United States of America

To my father, SAMUEL DAVID, one of the great men of all time, the hero of my life, without whom I could never have been me. I miss him.

Table of Contents

Acknowledgments

To Arlyn, my wife, my soulmate, the love of my life for whom I am forever grateful. You stand by me and with me; always no matter what. I love you more than words could ever express! Love you always!

To Shawn, our oldest son for whom we are so grateful to have in our lives. You are a great art dealer but even more so an extraordinary son who makes us so very proud. Love you always!

To Brett, our younger son for whom we are so grateful to have in our lives. You are a great art dealer but even more so an extraordinary son who makes us so very proud. Love you always!

To Alan, my dear brother; you stood by me and taught me everything you knew after Pop died. I couldn't have done it without you. Love you always!

To Mom you were always my champion; we never would have survived without you. Love you always! Miss you . . .

To Pop, you were my hero whom I have spent my life emulating on my mission to fill your shoes and make you proud. Love you always! Miss you . . .

To Bruce, my amazing brother whose life was painfully short, you are with us in spirit. Love you always! Miss you . . .

To Nick Lyons, my longtime friend who made this book possible twice. I am grateful to you for your friendship and your faith in me. Thank you!

To Tony Lyons for the opportunity to bring this book to fruition. Thank you!

To Zoe Wright, my editor with whom it is an honor to work. Thank you!

Foreword

What the great French auctioneer Maurice Rheims called a glorious obsession has become a positive mania. Mr. Rheims was referring, of course, to the activity of collecting, an activity that arises from the fascinating and often ambiguous relationship between people and objects of art. This relationship contains such diverse elements as a passion for beauty, a drive for self-glorification, a good bit of nostalgia, and a desire for a good investment.

The activity of collecting, as well as the collecting public and what it collects, has gone through an extraordinary period of change and expansion in the last thirty-five years. The use of that awful word *collectible* might be considered an indication of just such a change. Before World War II, the buying of antiques and objects of art was limited. Collectors were fewer; they concentrated their efforts on a narrow field and a time period that, for the most part, did not extend beyond 1850. They collected what has come to be called high art in furniture, fine arts, silver, some glass and pottery. Today it appears that everybody collects and, it seems, they

collect everything—Victoriana, Art Nouveau objects, Art Deco objects, Depression Glass, comic books, buttons, film posters, and even automobiles from the 1950s and 1960s—in addition to the painting, sculpture, and watercolors which are the subject of this book.

In *Collecting and Care of Fine Art* Carl David has written a manual for collecting and investing in fine art. The investment factor has increased in significance as the decline of the purchasing power of the dollar has led many people to feel that art objects are worth more than money and will increase in value over a period of time. But it remains the object itself that is *really* significant.

The real value of a work of art is in the idea the artist expresses in it and its levels of meaning to the person who acquires it. To have a painting that, over a period of time, reveals more and more to the collector and which by so doing enriches his life and refreshes his spirit—this is the real purpose of collecting. In fact it is the purpose of art itself.

RICHARD J. BOYLE
Director
Pennsylvania Academy of the Fine Arts

Preface

This is a manual for collecting and investing in art. As we progress, the difference between collecting art and investing in art will become obvious to you. It is my belief that art should be collected for sensual and intellectual enjoyment and for no other reason. There are, however, many factors that influence this concept, and their validity cannot be denied. Nevertheless, taking all such influences into account, one should select art for aesthetic reasons first and for all other reasons incidentally.

As a dealer in paintings, I am on the inside track of the intricate financial workings of the art market. Today, art is considered a commodity in which to invest money. It is a hedge against inflation, it provides sheltered dollars, and it can be enjoyed while your investment grows dramatically. Art is big business; huge sums of money change hands in the art world every day. Corporations, banks, investment syndicates, and individual investors are turning away from other money shelters and are putting their money into art. The appreciation can be extraordinary, frequently unmatched by any other investment.

In the chapters to follow, investments will be discussed in detail, but the emphasis will be on collecting art. It is difficult to separate collecting from investing since many of the same principles apply to both. Most important is to learn the principles, and learn them well; then decide for yourself whether to collect, invest, or do both.

In our business, we must consider both collecting and investing. In order for the gallery to operate profitably, it is imperative that we make our acquisitions with strong emphasis on growth potential and resale value. However, we are very careful about the quality of our acquisitions. We will not purchase a painting simply because there is a profit to be made—with one exception: if the profit is substantial and the turnover quick. Otherwise, we will not acquire anything that we would not be proud to own ourselves. That is the guideline we use in making our purchases. In a word, good taste. No matter what we buy or take in on consignment, we draw the line at the point where our integrity might be injured. We prefer to deal in paintings that are beautiful, but not all paintings are beautiful, and since taste is a highly personal matter, what does not appeal to one person can very likely appeal to someone else.

Art is available in all sizes, shapes, and forms, and each work bears its own distinct characteristics. Art should appeal to the senses consciously and subconsciously, as well as intellectually conceptualizing the nature of man in the universe. Whether the artist paints realistically, impressionistically, or abstractly, he conveys his message primarily by color, composition, and form. Even the

subtlest alteration of these essential variables can change the viewer's perception of the painting. An analogy is the written sentence; if one word is changed or moved, the entire meaning can be altered. As another form of expression, art too deals with the idea, translating it into visual form to be experienced by another of the senses.

There are many forms of art, but in this book we will be concerned with paintings, watercolors, and drawings, with an occasional allusion to sculpture. We will not discuss collecting prints because there are several fine books about that particular speciality. For example, *Six Centuries of Fine Prints* and *Fine Prints Old and New*, both written by Carl Zigrosser, are very complete surveys of the subject, which we would recommend to anyone interested in prints.

We will also omit discussion of contemporary art because in our opinion it is simply too soon to predict accurately future trends regarding long-term investment.

We hope not only to enlighten beginning collectors but even for the more experienced to clarify and perhaps dispel the various myths about art and to separate fact from fiction about investing in art.

As art dealers we have had the invaluable benefit of the distillation of three generations of collecting and dealing: that of our grandfather, David David; that of our father, Samuel David; and that of our own, Alan David (my brother) and myself. We are attempting to bring to you the accumulation of our collective experiences.

Chapter 1
How to Learn About Art

If you are genuinely interested in collecting art, pay very careful attention to the advice in this chapter. It will be the most important of any that is available anywhere, at any cost. One word describes the entire concept: exposure. Expose yourself to art. This is the key to the degree of success that you can achieve in the art market.

There are many avenues to explore to find the necessary education: museums, schools, libraries, galleries, art journals, and auctions, to name a few. Museums put great numbers of paintings on view, frequently arranged by artist, separated by century, and sometimes even distinguished by country, region, or school of painting. Guided tours and art courses are readily available at many museums, and there are museums in almost every major city in the country, so that access to their collections is rarely a problem.

There are, of course, universities, libraries, and bookstores everywhere in America and they provide nearly all of the reading material one needs, ranging from glossy coffee-table books to arcane scholarly tomes with no end

of footnotes, cross-references, and bibliographies. There are also several worthwhile and necessary art journals and periodicals to which one can subscribe, or find on the local newsstand, depending upon the sophistication of your neighborhood. *Antiques, American Art and Antiques, American Art Review, Connoisseur, Apollo, Art News, Arts, Art Forum,* and *Art in America* are among the best. They offer well-written articles and supply you with current information about exhibitions and developments in the art world.

Constant and frequent visits to art galleries are a must. There are always different paintings and painting exhibitions to view. Prices will either be posted or given upon request. This element in the educational process cannot be learned by reading the available literature, for it is generally considered indelicate by the art trade to advertise prices in art journals and trade magazines.

All types of art, from Old Master to Modern Master, can be seen and purchased in galleries across the country, but one of the little-known functions of the art gallery is that of educating anyone who is interested. Catalogs and other informative publications, prepared for exhibitions, are eagerly dispersed to the public, with the idea that in the future a recipient might purchase something from the gallery. Everyone enjoys the benefits: the gallery gets exposure for its exhibition and the viewer gets an education. Auctions serve a similar purpose, offering an education through descriptive catalogs, which include each work to be auctioned, photographs, size, medium, signature, information, provenances, and estimates of price expectations.

The auction itself is a splendid learning arena. Trends can be observed, and one can determine who is buying what, for how much, and why. The best way to find out what is really happening is to pay attention to the dealers. For the most part, it is the dealers who make the markets and create the trends, so careful observation of them will prove invaluable.

We will explore auctions in greater detail in a later chapter.

As I mentioned before, the basic prerequisite for successful investment in art is exposure to the various markets. Saturate yourself with art, live it. Take every opportunity to expose your senses to all forms of art. That is the one way you can absorb enough to become a sophisticated collector and investor.

This cannot be done hurriedly. It will take time—months . . . years. It all depends on the individual—how much one can digest, how soon the eye becomes discriminating, and how soon one's tastes, based on knowledge and judgment, develop. When you've set your sights on a specific school, or schools, of painting, seek out galleries that can furnish you with a considerable number of paintings you can view, compare, and examine. Should you find a painting that you feel that you cannot live without and you are confident about the purchase, then buy it. If you don't find anything at first, don't despair; there will be other paintings out there waiting for you. The fact that you have narrowed down the field is an encouraging beginning. Now is the time to return to the museums and the books to reexamine carefully and specifically the

school, or schools, of painting you've chosen. Make sure you understand the criteria for varying levels of quality. There are many factors in distinguishing good from better from best, but these must come from viewing the paintings and making comparisons rather than from verbal descriptions.

It was once stated to me that an artist should have something to say to the viewer. The degree with which he succeeds determines the quality of his work.

Some rare people possess the gift of knowing instinctively when a work of art is very good, or great, regardless of all influences. Others have the potential to develop this skill, if they can train themselves to see, not merely to look at something superficially. Most people use only their eyes and see only the surface, without involving mind and emotions to feel and experience wholly. The eye should be merely the vehicle for transporting a very real series of associative impulses to the brain. Effectively training your mind and emotions to work with your eyes will enable you to judge art as well as the professional.

This will probably take many years, but once accomplished, you will be privy to a very rare and fulfilling enrichment in your life. You will have, if you succeed, what very few people ever have, and that is rare good taste.

Chapter 2
Where to Buy Art

There are numerous sources from which to buy works of art. Marvelous galleries have been established throughout America, Canada, and Europe. Art dealers of note in America can be found in New York, Boston, Philadelphia, Washington, Chicago, Denver, Houston, Dallas, Santa Fe, Los Angeles, and San Francisco. In addition to these dealers in major cities, there are many fine dealers throughout the country, but it would be impossible to list them here. Such a list could never be completed because it changes and expands almost daily. For our purposes including only the major cities will provide an adequate guide.

Auctions are also available in great abundance throughout the country, but I do not recommend auction buying for the beginner. There are too many things to learn before one can bid safely and successfully, but more about auctions later. I also suggest that the beginner refrain from buying in the European market, for a variety of reasons, including currency fluctuations and economic factors. In your own territory there are laws to protect you as a consumer. International law can be very

complicated, and more complications are the last thing you want to add to your beginning efforts. Later you will have enough experience to venture into foreign markets. For now there is quite enough in the American market to keep you busy.

To select a gallery with whom to deal, get a solid recommendation from someone you trust. If you have no acquaintances who have enthusiasm for an art gallery exhibiting the type of painting that interests you, then telephone the museums in your city and ask for names of dealers and galleries with sterling reputations. The museums will be delighted to offer you a varied selection of names. When you visit the dealers, tell them about your interests, what you can afford, how many paintings you will want, and ask to be shown those that are available. Your visit has a dual purpose: to see the paintings, but more importantly to strike up a relationship of trust with one or more dealers. After all, the aim of a good dealer is to find the specific items his clients want. His task is not merely to sell paintings; the real satisfaction comes when he can match his client with paintings that are right for him. A dealer of impeccable reputation would not do otherwise, because ultimately he would lose clients and reputation. That isn't to say that some dealers are not above this kind of deceit, but fortunately word of a bad reputation spreads rapidly and is never forgotten. Unfortunately, some unsuspecting collectors are victimized in the interim.

The only way to determine the ethics and qualifications of a dealer is to look him over with care. Acquaint yourself with him and his gallery. Observe his appearance,

note his suggestions, the attitude of his staff, and the general response to you as a novice collector. If you are treated curtly or inconsiderately, leave immediately. There are many dealers who will be delighted to spend time with you in order to increase your appreciation of art. Ask as many questions as you can think of; take advantage of the dealer's knowledge, for at this stage, he is the one person who can lead you through the labyrinth of the art world.

I cannot urge you strongly enough to avoid completely any dealer who will not stand behind his goods.

It is traditional among better dealers to accept in trade, against another work of greater value, a painting you previously purchased from him. To illustrate, if you buy a painting for $1,500 today and decide to use it later as trade against another painting you prefer, you should be allowed a credit of $1,500 against the new work. In many instances the original investment will have grown substantially so that the credit allowed by the dealer will be much greater than the original purchase price. There is an advantage to the dealer to accept a trade back: it gives him another painting to sell after he has sold one to you. In a way it is an enticement to get you to spend more money, but it is an honest, universally accepted business procedure. However, don't expect to be able to trade a painting at any time. Art markets fluctuate, and sometimes a painting will not be as desirable when you want to sell it as it was when you bought it. You may have to wait for renewed interest in the artist before a proper trade becomes possible.

Where to sell paintings? Conditions for selling art are comparable to those for buying art. The seller will find

that some methods are better than others. At times auctions are ideal for selling paintings, if trends, timing, auction house, and the lots on offer are all compatible. Since we will devote a chapter to the auction and its advantages and disadvantages, let's focus on the dealer now.

There are two standard ways to sell a painting through a dealer. You can sell it to the dealer himself for an established price, or you can consign it to him for sale at a predetermined price. He will then proceed to sell it for you and take a commission, the amount agreed on by written contract before you consign the painting to him. Commissions range from as little as 5 percent on very large sums to as much as 30 to 50 percent for others. A fairly standard fee for most transactions is about 20 percent. The commission should cover any photographic, telephone, advertising, and entertainment expenses the dealer incurs in selling your painting, as well as his fee for his time and effort.

Another form of consignment specifies that the dealer pay a net price to you. The dealer will then ask a somewhat higher price for the work or collect a commission from the buyer. This method is very popular in that it provides the dealer greater flexibility when he negotiates with his buyer. It will be to your advantage to have a fairly precise idea of how much money you will want for your painting. If you know its value, you can readily complete your arrangements with the dealer. Don't play games by feigning ignorance. You'll only alienate the dealer and diminish your chances of selling the painting.

Here is an example of the kind of thing that happens to us several times a week. A person comes into our gallery

to sell us a painting by Albert Bierstadt, a great American landscape and mountain painter of the nineteenth century, whose prices can be absolutely extraordinary. And so it begins:

"Well, sir, that's quite a painting," I say. "Yes, isn't it?" he responds.

"Obviously you want to sell it or you wouldn't be here, right? How much do you have to get for it?"

"Haven't the vaguest notion," he retorts. "What do you reckon it's worth?"

Now the game has begun, and it's a no-win situation. I know very well that the painting (a view of Yosemite—25" x 30"—oil/canvas) is worth at least $250,000, and I know that he knows it too. If I offer him $200,000, then either I'm going to appear ignorant and uninformed or he will think that I'm trying to take advantage of him. If I tell him it's worth $250,000, then I'm right on the money, but where do I go from there? That may be all I can sell it for, and then I will have no profit.

I'm a dealer in a business that gives me great satisfaction, but to remain in business I must operate profitably. With this in mind, I make my offer, "I'll give you two hundred thousand for it," I say.

The reply is just what I have anticipated: "Well, So and So Gallery said it's worth two hundred and fifty thousand."

Perhaps because it's late in the day, and this hasn't been one of my better ones, I'm ripe for an argument. "Then go sell it to them," I suggest.

What happens next is fairly standard. "The other gallery would have bought the picture," he asserts, "but they

already have two others just like it." Such an excuse is obviously contrived. If a dealer has six great paintings by the same artist and a seventh comes along, he would be eager to buy it—unless the price or condition was out of all reason. A really good dealer would have to have taken leave of his senses to turn away top-quality goods merely because he already has examples of the artist's best work. As a dealer, I tell you, in no uncertain terms, that one cannot have enough of the best. After all, the major examples and the most beautiful works are the most highly sought after and therefore the rarest.

Since I would not increase my offer and the Bierstadt owner was anxious to sell, we closed at $200,000. At a later date I sold the painting for a sum between $250,000 and $300,000. Unreasonable for me to make a profit in excess of $50,000? Absolutely not, and here's why. If I'd invested the same dollars in a money-market instrument, I could collect a yield of approximately 12 percent or $24,000 in a year. And how about my risk and my overhead? What if the market for a great Bierstadt Yosemite painting had been temporarily satisfied, and there were no buyers for a year or two? That's a pretty substantial shock to absorb. In that case I'd be losing the $24,000 a year in interest, while the painting lay unsold. In two years nearly $50,000 would have accrued, so that if I sell the painting for $250,000, I would have taken the risk and come out even—nothing to show for two years of holding a valuable painting. Now it should be clear why my profit of over $50,000 is not excessive.

As long as you understand the dealer's position and negotiate reasonably, the honorable dealer will not take advantage of you.

In general, art transactions of $1,500 to $25,000 are matters of daily routine. To the outsider these are the essence of the gallery. Yet the gallery is really dependent on the sales of more important art at really big money to cover investment and overhead and to thrive. We negotiate deals for large sums all the time, and believe me, the risks can make your blood run cold, and the tensions are unparalleled. You rely on every source of brainpower available: the best of attorneys, tax specialists, accountants, consultants, bankers, and especially your own experience. Conferences go on until your eyes are bloodshot and you are dizzy, outlining every conceivable possibility, both good and bad. After all the analyses and weighing the benefits against the risks, you enter into actual negotiations. And sometimes if you make the purchase, you may wait years before you see the results.

This is the nature of the action that we experience. The excitement that exists at this level cannot be matched by any other. Even if the profit margin is slighter, the thrill of dealing in millions of dollars is uniquely exhilarating. It is definitely not for those who are faint of heart, for the stress can literally kill. Is it worth the risks? For me, yes. I could never be satisfied with simply buying and selling paintings on a small scale, even though it provides a living and a beautiful working environment. I am the kind of person who thrives on action, the challenge of the impossible, the sweet feel of success in closing a deal

that everyone shies away from because of insurmountable odds. I'm firmly entrenched in the belief that you can pretty nearly achieve anything that you set your mind to do—within reason of course—and though I haven't written this book to philosophize, I do believe that if you are going to derive the maximum pleasure from collecting and investing in art, you need drive and motivation to help you.

Chapter 3
How Much Money
Do You Need? Financing

Since the art markets fluctuate up and down just as the general economy does, it's nearly impossible to be completely accurate about the cost of acquiring art. There are, however, times of economic stability or periods of slower change when predictions of prices can be fairly on target.

A constant in the art market is the work of the Gothic and Renaissance periods. If you are lucky enough, you might discover a work of these periods in an attic, or in an unsuspecting shopkeeper's antique shop, where you might buy it for as little as $1,200 to $1,500. Through normal channels, though, an outstanding example of this period, which is rarely found, will cost you from $50,000 into the millions.

The paintings of the Mannerist and Baroque schools can be found more readily and for a lot less money—a few thousand dollars can buy a work in one of these schools. But keep in mind that even here the textbook names can run as high as hundreds of thousands of dollars; even millions. If a finished painting by El Greco were to surface, the price would of course be very, very steep. However, a

smaller decorative work by Frans Francken or Lucas de Heere could conceivably be had for under $10,000. As a rule the Baroque works can be bought more cheaply than the Mannerists. The seventeenth-century genre scenes, landscapes, still-life works, and portraits can cost as much as several hundred thousand dollars, especially for fine works by artists like Meindert Hobbema, Albert Cuyp, Rembrandt (in the millions), and Nicolaes Berchem. The Neoclassic works are not inexpensive except by comparison with the highly sought for works; a Goya or an Ingres, for example, can still fetch many hundreds of thousands of dollars, but many others can also be bought for $10,000, $15,000, and $20,000.

Paintings of the Barbizon School are probably the best candidates of any European school for acquisition at an affordable price. But there are exceptions here too—a great early Corot will bring $400,000 or better. The lesser names like Dupre, Troyon, Francois, and Jacques are still in abundance in the under-$10,000 range, sometimes under-$5,000, and have just barely begun to see their stars rise. The time to buy them is now, before everyone discovers them and drives prices skyward.

The Impressionists, Postimpressionists, Expressionists, Surrealists, Futurists, and Cubists all command very high prices in today's market. The French Impressionists and Postimpressionists are the most expensive (into the millions for the prized examples). But plenty of works by smaller names can still be found (other than Renoir, Gauguin, Monet, Manet, Matisse, Seurat, Cezanne, Degas, Pissarro, and the like), like Maximilien Luce, Armand Guillaumin,

Gustave Loiseau, and others, for under $10,000. The Surrealists like Dali are also very highly prized ($50,000 to several hundred thousand dollars) and the German Expressionist works are very expensive (into the low- to mid-hundred-thousand range). The Futurist, Cubist, and Abstract schools are in the $200,000 and under range, but some examples can be found for as little as $10,000.

It must be said that in all of these schools of painting, drawing, and sculpture, there are always minor examples, slight sketches, and smaller less typical examples which can be bought for *much* less than prime prices. Outstanding portraits by Renoir may bring over $1 million, while there are also small landscape sketches and drawings which are quite pleasing and can be had for $9,000 to $15,000. So, if it has always been your dream to own a Renoir, don't despair. You can still fulfill your desire at a reasonable price.

The difficulty in defining a price structure is caused by the many variables: quality, size, subject (some bring more than others), medium (oil compared with watercolor, drawing-oils generally bringing the highest dollar), the degree to which the work is finished (the more finished the higher the price), provenance, and other factors influencing prices in the art market (see chapter entitled "What Influences Prices?").

There are several American schools of painting that can be placed in approximate price ranges.

Colonial portraiture can frequently be acquired for as little as $2,500 when the artist is unknown, but can also become very expensive when you find a portrait of a

known subject by John Trumbull, Charles Willson Peale, or John Singleton Copley, for example. For the leaders in that division you can expect prices upward of $500,000, but often works can be bought for as little as $35,000 to $75,000 for either lesser examples by these top-ranked artists or for portraits by lesser-known artists.

Primitive paintings usually have a ceiling of $300,000 or better for rare works by artists such as Edward Hicks. The more normal range would be from $1,500 for anonymous works to about $100,000 for paintings by Ammi Phillips or Horace Pippin, but the prices touch everything between those extremes.

Genre and Realism have found their way to higher prices in the market. The most recent was the near $1 million for a painting at auction by George Caleb Bingham. If a top-notch oil painting by William Sidney Mount were to be sold today, the price would be at least comparable if not greater. Thomas Eakins and Winslow Homer can bring close to the million-dollar mark and, for important examples, over a million. Again, though, you might be able to find a small study or watercolor or pencil sketch by Eastman Johnson and add it to your collection for $6,000 or slightly higher.

The work of the Hudson River School can be had for as little as $2,000 to $7,000 and as much as the low millions for a truly major example by Albert Bierstadt, Frederic Church, or Thomas Cole. The bulk of paintings in this school is still relatively inexpensive ($12,000 to $60,000) considering the quality you can find in works by artists such as Samuel Colman, James Smillie, and James Hart.

The American Barbizon School offers great bargains, especially with works by artists such as Hugh Bolton Jones, Homer Martin, and Alexander Wyant that can still be bought for under $10,000 in many instances. Of course, a great George Inness will attract $250,000 or more, but he is the most highly revered of the Barbizon painters.

American Impressionism derives from the French tradition, but not its prices. Paintings, watercolors, and drawings by people such as Theodore Butler, Martha Walter, and Ernest Lawson are available for under $10,000. Good works by Mary Cassatt, John Singer Sargent, Childe Hassam, Frederick Frieseke, William Merritt Chase, Theodore Robinson, and James Abbott McNeill Whistler can easily reach up to the $200,000 to $400,000 price range.

The Ashcan School (which is also known as The Eight) has been highly sought after for many years now. Of the group, Prendergast brings the highest prices (major works up to $400,000) but nice drawings and small paintings by Robert Henri, Everett Shinn, and William Glackens fetch $3,000 to $5,000—very affordable. In the middle range of $10,000 to $75,000 there is a great deal of fine-quality Ashcan material.

For as little as $1,500 Still Life paintings of the nineteenth century by the least-sought-after painters such as Benjamin Champney can be bought, and there is a plentiful supply of works in the $15,000 to $60,000 range by artists such as Paul Lacroix, George Cope, John Francis, and Severin Roesen. The highest price range of $100,000

to $400,000 includes William Harnett, Raphaelle Peale, and James Peale (eighteenth and nineteenth century).

Western paintings can be purchased for $1,000 to $1,500 if the artist is unknown or if the work is a minor example, but a great Frederic Remington or Charles Marion Russell can reach into the million-dollar range. Also, any number of today's painters of the West command very healthy prices for their work. It is not uncommon to get $50,000 to $100,000, but as I stated before, the middle grounds ($1,000 to $10,000) are well supplied with paintings.

Regionalism, early twentieth-century Realism, Abstraction, and Expressionism can all be found in the marketplace for $10,000 to $20,000—modest examples by artists such as Thomas Hart Benton. But substantial works by Edward Hopper will be over $100,000.

It is evident that price ranges vary greatly, and though there seem to be a great many works available at the highest prices, there are really many more in the middle and lower ranges. There is no reason for you to feel intimidated by the telephone-number prices you hear if you remember that there is a very wide and plentiful market of goods in the $1,000 to $10,000 range. You may even find works of art for as little as $350, although you'll probably not be satisfied with most things at that level.

Even if you are seeking status and are only hunting for "name" art, there is a chance to be successful in your quest. You won't be able to buy any major examples of the big names if you're on a shoestring budget, but you can manage to find a drawing or watercolor or even a very

small (4" x 6") oil sketch. Nobody will ever claim one of these to be great, but it is a "name."

If you can afford large sums of cash, your best bet for quick appreciation will be French Impressionism, Post-impressionism, Expressionism (German), Cubism, American Genre and Realism, Hudson River School, Western, and Impressionism. In recent years works in these categories exhibited the most extraordinary growth. Prices have broken records repeatedly and will probably continue to do so in the foreseeable future. Of course, to be safe, it is vital to watch with extreme caution all of the factors I outline in the chapter on price influences.

For the greatest growth potential with the smallest investment look to the seventeenth-century Genre/Landscape, Hudson River School, American Barbizon, American Impressionism, and Ashcan. In this category, the European Barbizon and the Hudson River schools probably provide the best opportunity to spend from $5,000 to $15,000 and take possession of a little jewel of a painting by perhaps a lesser artist of the school. Frequently the second generation painters, as good as, or better than, the first generation artists of a school, don't command the same extraordinary prices. For that reason they are an excellent investment, which can show a handsome profit in the years to come.

As in any arena, be it the theater, the stock market, or the world of politics, the spotlight will illuminate only a certain number of actors, stocks, or candidates at any one time. It depends on who and what is fashionable and who and what is well promoted. The same principles

apply to paintings. Those that are fashionable and highly promoted are considered to be the best. Others are overlooked, not for any lack of quality but because they are not the type or school that everyone is eager to acquire, and these are often the best candidates for collection or investment. They can be purchased inexpensively (frequently from $1,500 to $6,500), and there is an abundant supply of them at almost any time.

Financing can be a concern for many people who develop an interest in collecting or investing in art. Here are several methods that have proved successful.

If the sums are sizable ($50,000 or better), a bank with adequate experience in the art world might be considered. If the collateral—such as your potential art, your house, life insurance policy, or jewels—is freely convertible to cash in the marketplace (in the event of a default), the bank might willingly assume the risk. A couple of other basics must be present as well: you must be a good credit risk, your income substantial, steady, and predictable; and the art you want to buy must be of readily recognizable quality. Banks are eager to participate only in ironclad, watertight, fail-safe deals, and they rarely enter into a financing arrangement that falls outside their conservative requirements, especially when it involves works of art, unless they are convinced of its total security. They know that sometimes the art markets are volatile and paintings or sculpture are not easily convertible to cash, unless the art is of such top-notch quality that it can be quickly resold.

If you do procure a loan, don't expect it to extend for a long term. The banks are itchy to get their money

back quickly, within a year at most. If you repay the loan promptly, they'll probably accommodate you more readily the next time you want their backing to buy a work of art. Most bankers would prefer you to repay your loan steadily and ahead of schedule if possible, and then borrow again. They feel there is less risk in a reliable series of quick loans and repayments than in tying up funds for a longer period.

Banks provide loans for stocks and bonds; the art markets are at least as secure as the stock market, and when you're talking about *fine* works of art, probably much more so. Distinguishing *fine* works of art from works of art is the crux of the problem. Everything depends on where the banks place that line of demarcation.

A popular way of financing your acquisition of art is through the dealer from whom you purchase it. If the price is over $3,500, the dealer will often allow you to pay over a short span of time—from one month to three months are fairly standard pay periods—but be prepared to put one-third to one-half down immediately. If you do make such an arrangement, don't expect to take possession of the art until it's completely, or at least mostly, paid for, unless the dealer knows you fairly well or has had prior satisfactory dealings with you. Of course circumstances vary, but usually the greater the amount of money, the longer the term of payment. When the price exceeds $100,000, the payment time can sometimes be stretched to six months or longer. You are generally not charged any interest.

Remember, however, that the dealer will finance only a long-time-favored client or one with a promising

future— especially if the works you select are very much in demand. The paintings, sculptures, watercolors, and drawings for which people are knocking down the doors are not the ones for which to plead long-term payment. No dealer in his proper senses will want to stretch out his capital inflow when other clients are eager to pay in full immediately.

A fairly standard procedure involving paintings in the $3,500 to $25,000 range is to pay one-half down and the balance in thirty days if it is impossible to complete the transaction in one payment. Dealers are for the most part sympathetic to the high cost of art (don't forget, they have to pay for it too) and will usually be amenable to working with you.

Another method of payment which appeals to some collectors is the trade arrangement. For example, you're in a top-notch gallery on the East Coast, and you spy an oil painting in a back room that you feel you must have. On closer inspection, you see the signature: "Winslow Homer." Your heart sinks; the price for the little gem is beyond your highest calculation: $275,000. You could have handled $100,000, maybe $125,000, but where to get the rest? Forget the banks. You can't squeeze another nickel out of them with all the mortgages you have your name on, and besides, your corporate loans outstanding are at an all-time high. The dealer won't give you enough time to make it prudent to take terms—you couldn't fulfill your obligation in a month or two anyhow.

Another thought: you've heard that art dealers are sometimes open to the notion of a trade, or at least a

combination of cash and trade. You don't want to relinquish any of your art—it took too long to acquire it—but you do have some very fine jewels stowed away in the vault. Nobody uses them; the insurance is prohibitive and they're a bit too gaudy for current styles. The idea is presented to the dealer: take the jewels in exchange for the balance of $150,000. He accepts. He knows that the value is there and that it will be easy to convert the jewels to cash. He also has a wife who adores fine jewels so that there is a ready domestic market for some of them.

Trades can work very well if you have a commodity the dealer can use. We've experienced propositions involving parcels of real estate, jewels, automobiles, yachts, oil overrides, royalties, and of course, paintings and other works of art. Some of these trade items are undesirable to the art dealer, but obviously still have a market through their own channels and can be converted to cash through their respective brokers.

When the trade is acceptable, it can be even more beneficial than cash to both parties. You dispose of something that you no longer want, and the dealer may be able to eke out a little more profit (though he may have to wait for the right marketing opportunity). Frequently, new inventory is more precious to a dealer than cash, depending on the marketability and quantity of his stock reserves. And for the buyer, when his taste and good judgment lead him to a more costly bracket than he ever intended, a trade may be the only solution.

Chapter 4
What Influences Prices?

Let us here explore the most significant components of price structure in the art market and how they combine to influence costs. Let us first examine two different factors, internal and external. The internal factors are the quality, size, date, medium, and condition of the work of art itself. The external factors are those that relate to the work, such as museum and dealer exhibitions, promotions, trends, publicity, prior sales records, currency fluctuations, economic conditions, and supply and demand.

It is important to recognize that these elements do occur in varying combinations and that each particular combination has differing consequences. The complexity lies in the fact that a work of art is unique, possessing its own characteristics; there is no absolute standard by which to measure its value.

Quality is probably the single most important factor that affects price in the art market. For the very best quality, prices will be highest whether the marketplace is reached through a dealer or an auction. We recently paid well over $100,000 for a painting by Frederic Remington entitled

"Trooper of the Plains." It depicted a very rugged cavalry-man standing next to his horse in the hot summer sun of the desert in the barren Southwest. The cavalryman had the convincing look of a tough soldier whom you wouldn't want to be your enemy. He was posed with pride and readiness, eager for a challenge, his rifle hanging at his side, ammunition draped around his shoulder and waist. His horse conveyed the fatigue it was suffering, waiting obediently for its master, while swishing its tail and kicking up the dust. The painting was so realistic that it was overwhelming; the quality was unique for an easel painting, and therefore it enabled us to ask $225,000—a record-shattering price for such a small work (18" x 22") in oil. After a few days of serious negotiations we sold it for $200,000. At that particular time (1977) that was about the maximum price that the market would bear. Three years later the same painting could be sold for $400,000. The quality hasn't changed, but economics have and so have awarenesses. There are now far more collectors who want this kind of painting, and there are now fewer of this kind of painting available.

The laws of supply and demand often wreak havoc in the price structure. If there is a shortage, then the price of any available top-quality work will most definitely be driven upward with the "Go find another one" philosophy working full tilt. The serious collector understands the tremendous rarity of great works and will not be frightened by an astronomical price. He might try to negotiate with a close offer, but not one that is absurd or insulting, for he knows full well that in the wings there is another collector who will most likely pay the full price.

If there is a severe dearth of prime-quality art, then prices of the second- and third-generation quality works will increase. In dealing with quality, a rather subjective factor, an important consideration is the reputation of the artist. If our painting, "Trooper of the Plains," were painted by some little-known provincial artist, rather than by Frederic Remington, quality notwithstanding, the price would have been at most $12,500 instead of $200,000. Remington is the greatest painter of the late-nineteenth-century American West, and the most highly sought-after artist of Western paintings and bronzes. His name alone commands high prices, but the quality is there also to back it up.

There are many instances in art trading where quality is present and the name is not, and yet prices are high anyway. This is the effect of publicity. If the press gives a favorable review to a show of little known work by a virtually unknown artist, people will flock in in droves to see the exhibition, and frequently will buy the items so highly regarded by the press. In contrast, a bad review can have varying effects. It can destroy the possible success of an exhibition or it can attract masses of people, either because the credentials of the reviewer are less than valid or because curiosity makes them want to see what could possibly be so awful.

Any publicity, good or bad, is better than no publicity. Even a bad review is better for a gallery exhibition than none at all. The absence of a review could even promote reductions in prices, for lack of interested buyers.

Exhibitions are very costly, so that if few people show active interest, the law of supply and demand will reverse

the outcome. As demand slackens, inventory increases, and prices drop. Publicity in general stimulates prices and sales. The greater the publicity (advertising, circulars, private viewings, and so forth) the greater the interest and therefore increased demand, with higher prices.

Promotion plays a critical role in stimulating sales. Under some circumstances, it can even be responsible for overlooking quality. If the propaganda is impressive enough, many people, cultlike, will respond and in turn drive prices upward, or at least maintain an upward pressure on the price ceiling.

There are further possibilities. For instance, if the quality of art is unsurpassed and the promotion and publicity of an exhibition are successful, the prices of the items in the show will likely be very high. If an exhibition of American Luminist paintings, for example, sells out, then the next available group of similar works (either on exhibit or offered for private sale) will continue in the same direction—higher prices. A new trend will have begun. It may have been started either by a museum or by a dealer.

Promotions and exhibitions by museums and dealers spur interest, and when the interest spreads, people begin to clamor for those particular works. When they discover that their friends have an example, they want one too. Before too long it becomes fashionable to collect works of this sort—recently shown at the Whitney, the Metropolitan, or the National Gallery. In this regard art assumes the role of a status symbol.

Trends are not always stable though, for fashions change. What is a craze this month may be passé next

spring. Trends seldom change overnight, however, and sometimes continue for a great many years. I don't anticipate, for example, that French Impressionism will ever be abandoned for some newly sought-after school of painting.

A few years back, English portraiture of the late eighteenth and early nineteenth centuries suffered a terrible price failure. It was no longer fashionable to collect the full-length flowing portraits of young men, women, and children painted by such wonderful artists as Joshua Reynolds, George Romney, Thomas Lawrence, and others. Tastes changed, and people just stopped buying them. Collectors became interested in other schools of painting such as the Pre-Raphaelites, which, with few exceptions, had been fetching minimal prices. Suddenly, as a new excitement was generated, such painters as William Holman Hunt, John Everett Millais, Ford Madox Brown, and Edward Coley Burne-Jones, which a few months earlier could be had for a song, soared in price.

Many years back, the aforementioned English portraits brought very high prices ($50,000 and better—and that's when $50,000 was a decent sum of money), then the vogue changed and prices eroded. For years beautiful decorative portraits of spectacular quality were virtually unwanted. In 1980 interest in portraits was renewed, and they were in fashion again. Prices quickly began to build to the old levels. But this time there were additional influences at work.

Worldwide inflation, causing the buying power of most currencies to erode, was severe enough that tangible

assets, intrinsically valuable, became useful hedges against monetary loss. In times of economic instability, one of the safest shelters is works of art, especially paintings of very fine quality. So prices of art rose and will continue to rise as long as these conditions persist, increasing in much greater proportion than other inflated prices.

Like anything else, however, this aspect of price influence is also subject to change. For a decade foreign buyers created new markets in this country. The Japanese in particular were very active in purchasing French Impressionist and Barbizon School paintings, but they also backed out of the market periodically when domestic problems interfered. That happened when rising energy costs put Japanese industry under such pressure that there was a slowdown by Japanese investors in importing luxury items. But since conditions vary from country to country, other collectors and investors from other countries, including our own, soon appear at the auctions and dealers' galleries. The disappearance from the art scene of one country's buyers is seldom noticed, because of their quick replacement by another's. Consequently, certain works of art which had never been deemed investable are now being looked at twice—with respect for their aesthetic as well as their monetary value.

Taxes and import fees are other significant factors to consider as part of the total price structure. The Value Added Tax (VAT) of 15 percent in England has on occasion hampered the sale of art. The VAT is a tax on luxury items. If a dealer buys a painting for $25,000, planning to turn it around for $30,000, he has to remember that the

purchaser will be obliged to pay the additional 15 percent ($4,500) so that the real price will be closer to $35,000. This is in itself inflationary, so that the price is higher than the buyer expected. Or it causes him to lose interest entirely. If you buy the work of art for export and accompany it out of the country, you will be sent a refund of the 15 percent after filing the proper forms. You will have to pay the 15 percent initially though, so be prepared for it. You will not be charged any value added tax if you buy the art from outside the country and have it shipped to you.

The VAT is really the equivalent of our sales tax, except that the rate is roughly double what we pay here. If you buy art in any of the Common Market countries, you will be assessed a tax similar to the English of approximately 15 percent unless the art is exported.

Some countries also impose import taxes on art. Spain levies a 5 percent duty on any art (including Spanish art) which is brought into the country. An import fee for the art of one's own country seems incompatible with the effort of that country to regain possession of its own treasures, but there it is.

The combination of trends, economic conditions, and the availability of quality art recently created new possibilities for growth and has completely changed the face of the art market.

In 1974, the Whitney Museum Of American Art staged an exhibition of American Folk Art of epic proportions. From that moment a craze for folk art developed. Before that, the market had been limited to knowledgeable collectors, dealers, and museums. Now it exploded in

every direction and caused a storm of activity in what was a relatively quiet market.

We were inundated with requests for folk art—dozens of telephone calls every day for weeks on end. The focus then shifted to more serious collectors, who continued to contribute to the upward price spiral by vying for the same, now more limited, goods.

Another not illogical factor in the pricing of art is the effect of a dealer's reputation. When a dealer has a reputation for handling only the finest quality, he may offer a number of little-known items to the market, charge steep prices (if the quality justifies it), and people will buy them eagerly. They have confidence in the dealer and expect to pay his price, because of his judgment and integrity. His name guarantees even unknown or little known works as pieces of the same fine quality as his "important" offerings.

Top-quality works of little-known masters of any century will fetch very high prices if there is more than one buyer involved in the transaction. Frequently though, they can be had for very little money, either because they were overlooked or because the examples are atypical enough not to be recognized as works of the artist.

In 1968, my father stumbled across a painting in a museum in the Carolinas and asked the director who the artist was. "Her name is Martha Walter," he said, "and she lives in Glenside, a suburb of Philadelphia."

Martha Walter had had a fine reputation, especially for portraits of mothers and children, in the period 1900–1940, but since then she had faded into obscurity. At this accidental encounter with her work, my father was

intrigued. He decided to track down the painter to her home in Glenside.

There she was, ninety years old, surrounded by a houseful of her own paintings. They were stacked everywhere—along every inch of floor space, up against the walls, jamming the bedrooms, dining room, living room, basement, and garage. My father was absolutely thrilled to the bone—an entire inventory of beautiful full-quality paintings, which had never been properly cleaned, framed, or presented. What potential existed in that house! An art dealer's paradise.

Nobody told him, though, that Martha Walter didn't want to sell any of her works. She was independently wealthy, and her paintings were her children. She didn't want publicity and fame, and she certainly didn't want to be pestered by any art dealers. To her they were just a slick group of commercial vipers who wanted to profit by her talent. "Miss Walter," my father proposed, "I would love to have an exhibition of your paintings. We have the proper background and experience. We are one of the most prestigious galleries in America. Our space is uniquely generous, and our mailing list is the envy of our industry. We could make your name a household word. Your work would be sought after by collectors everywhere." After a pause, he received a defiant glance followed by a hiss. "I'm not interested."

"May I call you Martha?" he inquired charmingly.

"Call me what you like," she responded.

"Martha, look, your work is beautiful—it's just not fair to hide it like this from the public. It's been too many

years since you've exhibited anything, and it's damned well time. I'm not leaving until I get a positive commitment from you," he finished adamantly.

"I'll think about it" was all she said.

"Fine, I'll call you tomorrow." And he smiled optimistically.

Well, the next day at about two he was no closer to success. My father, who was a crack pilot, confessed to me that skirting violent thunderstorms in the company airplane was far less challenging than dealing with this spirited old lady, who tugged at his heart even while she twisted his guts. After several more sessions with Martha, he succeeded in signing contracts with her for an exclusive arrangement to restore, frame, publicize, promote, and exhibit her paintings.

Victor Hammer of the Hammer Galleries in New York was dying for a show of her work, which he had seen at our restorer's studio in Manhattan. My father agreed, concluding that it would help our effort substantially if New York collectors discovered her first. After all, if something is fashionable in New York, then its chances of catching on elsewhere are much better.

The exhibition went off with astounding success. Hammer sold a great many paintings. We subsequently staged a major exhibition and publicized it in grand fashion. We sold over 60 percent of the paintings in the exhibition on opening night. The main thrust of the show was the collection of impressionistic New England beach scenes, imposing park scenes of the Luxembourg Gardens in Paris, and elegantly expressive portraits of mothers and

children, at which Martha excelled. The prices ranged from $2,500 to $15,000 for works by an artist who was virtually unknown to the market in the late 1960s. Interest in her work revived from that moment.

Martha Walter died in 1976 at the age of a hundred and a few months, but thanks to my father she enjoyed huge success, fame, and prosperity in her own lifetime. In 1977, my brother Alan and I bought from her estate the entire body of oil paintings, watercolors, drawings, and monotypes. To be fair, we let Victor Hammer submit first offer, but we knew we would have to bid higher for sentimental reasons since our father began this endeavor.

Today the prices for Martha's paintings have increased dramatically. The beach scenes that used to bring $2,500 now sell for $9,500 to $17,500, and the top end portrait prices of $15,000 in 1968 are now selling for as much as $50,000 to $60,000. The reason is not only inflation, but a growth in the demand and general appreciation of her work. The quality factor was always there, it's just that today more people have come to recognize it.

A work of art that bears a good name but is only of modest quality will generally bring only a modest price. Whether it is an American Impressionist painting by Theodore Robinson or a seventeenth-century Dutch painting by Jan van Goyen, if the work is downright ugly or of genuinely poor quality, then the price will invariably fall below the normal range, as well it should. Not every work that an artist produces can be great. No one can produce at the same level all the time; to expect otherwise

would be unrealistic. Consequently some works are better or worse than others.

Among the complex circumstances that affect pricing, the elements of size, medium, and condition are significant. The adage of "if something is good, then more is better" is generally applicable to paintings, watercolors, drawings, and sculptures. The outstanding example is sculpture. If a nine-inch Degas bronze of a dancer is worth $20,000, then a bronze twice the size on the same subject will be worth at least twice that figure, maybe more—that is, provided the quality remains consistent. (We are dealing with limited edition sets, and both pieces are from sets of approximately the same limitation—that is, the same numbers of figures were cast of each.) A four-foot Degas bronze would bring an even more substantial price. It's as though these works of art are sold by the inch, and preposterous as it sounds, prices can often be predicted accurately by just such a calculation.

If you watch the auctions, you will see the development of the pattern, and the correlation of price to size. Oil-painting prices reflect the influence of this phenomenon in even greater degree. If a 10" x 14" landscape by Renoir sells for $45,000, then a comparable example that measures 20" x 30" should be worth $125,000 or more, depending upon quality, coloration, and date, as well as size. However, when a smaller work is of significantly better quality or of a more highly sought-after period, its price may exceed that of a larger work. A small gemlike work will be worth more than a large everyday example by the same artist. The first questions that a dealer will

ask when a painting is sold concern the artist, the period, the size, and the price.

Remember that sculpture may or may not be of a limited set, but paintings are usually unique. Prices reflect this. Even when an artist like Monet painted the same subject several times, as, for example, "Water Lilies," each painting is nevertheless one of a kind. One is not a copy of another, none is born from a cast, differing only in edition number, the final chasing by the sculptor, or the application of the patina. The same is true of watercolors and drawings that are not produced by a mechanical process. Each creation reflects individuality, so that differences in size are more erratic, less bound to restriction. Even if they are similar or identical in size, they are not out of a cast, so that prices are equally free of restriction and therefore exhibit greater mobility and spontaneity. That isn't to say, however, that prices for paintings, drawings, and watercolors are any less contingent upon quality, supply and demand, economics, publicity, and the other factors.

All works of art, including sculpture, are marked by their condition. If they are in pristine condition—and if all other factors are equal—they will be unaffected by price erosion. The more the restoration, though, the lower the price; any suspicion that a piece of art has been restored is a negative factor. The work of the original artist is no longer considered to be intact. Since it is not completely original, the price will be in some degree commensurate with the amount of restoration. If a painting is totally restored, then, in my opinion it is a copy by

the conservator and nothing else, and the price should, and most likely will, echo this circumstance.

But if a painting has been cut or has suffered minimal paint loss because of severe temperature and humidity fluctuations, it can be restored to maintain the integrity of the work itself, and it won't—and shouldn't—suffer anything but a small reduction in price. In most cases the price reduction will be directly proportionate to the degree of restoration. ("Restored to maintain the integrity" means making only vital repairs. A conservator's copy is an unjust, unnecessary interpretation—a flagrant abuse that distorts the artist's intention. The differences are obvious to the trained eye.)

Nevertheless, the extreme rarity of a work of art will maintain price, even when a large degree of conservation was done. Being the only one or one of ten in the world makes a high quality work of art virtually priceless. Items this desirable can be found only among works by such masters as Leonardo Da Vinci and Michelangelo.

Situations of limited supply and great demand can occur naturally or can be created. The result is the same. If there is a shortage of sought-after works of art, the prices of those works will rise whether the shortage is contrived or real. If every item in Picasso's estate were put on the market at one time, the prices would plummet. Part of the reason that prices in the art market remain high is the knowledge that one cannot purchase something at any time he chooses. If one could, then there would be nothing unique or individual about purchases of art. The whole process would resemble supermarket

shopping. Instead, it is speciality selection, with no danger of dilution.

Picasso left roughly 1,885 paintings, 7,089 drawings, 3,222 ceramic works, 17,411 prints (1,723 plates), 1,228 sculptures, and 6,121 lithographs with 453 stones, as well as several rugs and tapestries. Imagine the glut on the market if it were all released at the same time. A staggering effect! Market prices would probably shrink by at least half.

The date or period of an artist's work can also be an important factor in the price. Some periods are considered better than others for certain artists. For instance, in the case of John Henry Twachtman, a member of an American group of painters known as The Ten, the early formative works do not bring as much as the later works. Even though many are far more poetic and beautiful, the paintings of his early and middle period do not command the prices brought by his later-period works, which are thought to be more stylistically and technically developed. And they were also painted in America, which heightens the interest.

For some artists, later works are less valuable than the earlier works. A perfect illustration is the early work of Jean Baptiste Camille Corot, the French Barbizon painter of the nineteenth century, which can sell for upward of $350,000 a painting; a later work of comparable size might bring only $75,000 to $150,000. The reasons for this are rather complicated; they come down to the fact that to the connoisseur's eye the earlier works are superior.

Typically, American subjects by American artists usually bring more money than foreign subjects by the same

artist. The work of Albert Bierstadt is considered far more precious when the view is American (Yosemite or the Rockies) for example, rather than Swiss or Italian. We acquired from the Whitney Museum of Western Art in Cody, Wyoming, a strikingly beautiful view of the Jungfrau, Switzerland, which measured 54" x 84", oil on canvas. It was one of Bierstadt's masterpieces, one of his breathtaking panoramic landscapes with jagged peaks, waterfalls, mist-enshrouded mountains, and lush green foliage. We got a substantial sum for it when we sold it, but had it been an American subject, the price would have been triple. It was a connoisseur's painting, and it is now in the collection of one of our clients who had the good taste to recognize its very special quality and buck the tide of popular fashion.

Finally, it should be said that none of the influences of prices in the art market are mutually exclusive of the others. The permutations and variations are so great, however, there can always be an exception.

Chapter 5
Long- and Short-Term Investing

Investment in art can be either long- or short-term. Investors who are collectors at heart do not really anticipate an overnight kill in the art market. This kind of expectation is unrealistic and contrary to the aesthetic pleasures that are derived from the practice of collecting fine art. Serious investors often have a deep sense of appreciation for the art, which supersedes the notion of making money—at least in the immediate future. They know that the long haul will afford them substantially greater benefits both aesthetically and financially and that they can build collections much more successfully over a longer period of time.

If you are collecting during inflationary times, the chances are that you will pay very high prices for top-grade works; you might even overpay to procure certain things which are either very rare or very highly sought after by knowledgeable collectors and investors. It makes sense to overpay in such situations as long as you intend to keep the art for a minimum of a year. The amount of your overpayment will vanish over a period of time because

of inflation and appreciation. Prime quality works have proved this consistently, although in certain economic situations it might take a substantial amount of time to see this occur—not just one year, but perhaps as many as five to ten years.

If you buy right—not just the number of dollars you invest but the kind of art you buy—the results can be spectacular. Fluctuations in trends can be outridden. Depressions can be endured and even taken advantage of if you have substantial discretionary money. In situations of severe economic stress, all kinds of art will surface for cash; if you have the cash, you can call the shots and begin to collect your choices. Collecting works of art is generally a luxury, so that in times of economic disaster, a fair segment of collectors and investors will need to bail out to finance their necessities. The works of art you acquire this way for small (at least by comparison to peak prices) sums will eventually bounce back in value when new economic cycles develop. All economic cycles last only a limited time before they phase out and are replaced by others. There is a long economic history to prove this. So, if you can sit tight and wait it out, you can not only make a fortune by investing properly, you can also wind up with a highly respected collection of art.

Long-term investing offers tremendous growth potential; you can invest in the things which aren't yet fashionable, wait for the popular trend to start, and then sell them in part or in total at a great increase in price. As dealers we love to make just that kind of investment—it works and works well. On several occasions we have bought the

estate of an artist's top-quality but little-known work. The first thing we did was clean and frame a half dozen paintings, then store the rest and forget about them. We would exhibit one or two every so often, and perhaps sell one for a substantial figure.

Eventually (perhaps as much as ten years later) when we felt the time to be right, we would mount a major exhibition of a group of fifty or sixty works. At this time we would embark on a program of mass advertising and publicity in the art journals, radio, newspapers, and perhaps even publish an article in a national magazine. We would then begin to sell the paintings (but with the proviso that those sold remain in the exhibit, with "sold" stickers next to them, until it was finished).

Six months to one year later we would stage another major exhibition of comparable works but at even higher prices. The question "Who is this artist? I've never heard of him," is almost never asked again. The intense publicity establishes the artist's credentials and obviates the need for an explanation for the high prices—which will be even higher next year. People begin to buy not only because of the artistic appeal, but also because they know that whatever they purchase will enjoy a steady rise in value as we raise our prices. They are convinced—and correctly so—that their investments will produce substantial growth.

This isn't to say that the process of growth is automatic. The quality of the work must be present—and the gallery from which you purchase must have an impeccable reputation. The idea is that your purchases will be protected from any loss in value, or even stabilization, by a

long-term program of exhibitions and publicity. The gallery handling the estate of the artist will work to promote interest and brisk sales until there are no more works of the artist available for acquisition. Therefore, your investment automatically increases in value, because demand exceeds supply.

Taking a long-term position does not preclude the possibility of buying, selling, or trading up to enhance your collection. Your tastes may change and your income might grow to the point where you can raise your level of quality. At first glance this may seem like short-term investment because of the turnover, but in effect these exchanges are merely stepping stones in the path of long-term investments in art.

There are art-investment syndicates into which you may funnel large sums of money for a long term (up to ten years or more depending upon the arrangement) and from which you may profit handsomely if their ventures are successful. The terms of these organizations vary, but the basic idea is either to make a few substantial-size investments, which are held for a long period of time and then sold at a profit (divided among the investors as a capital gain) or to make many investments (liquidated on a frequent basis, treating the profits as ordinary income). This latter type of enterprise is primarily designed to make money rather than to shelter the dollars.

Syndicates are investment-slanted, and are not generally subscribed to by serious collectors except when they have excess funds and want to multiply them so that they can reinvest in art. No one in the fund actually gets to

keep the purchased art for more than a short time. Clearly the concept is to make money, not to collect art.

The only disadvantage in a long-term investment program is that your money may be tied up indefinitely; you are locked into the fund. But if it is successful, as many are, you will also enjoy considerable profit and continued opportunities for very rewarding investment. You won't have any administrative headaches, which are time-consuming and annoying. All you need to do is invest and relax. The dealers who run the syndicate will tend to all the details.

Short-term investing is quite another game and is one that has few advantages. To invest in many works of art at one time with the idea of selling quickly, one should by definition become a dealer. The works would have to be very salable so that profits could be realized. Dealers, for the most part, are involved in short-term investment. They must have a constantly changing inventory, a good assortment of successful-selling paintings or sculptures to provide a steady flow of capital and the means to purchase new works as they become available. Quick turnover is very important for most dealers, for it frees capital to take advantage of opportunities. If profits are smaller, they are more frequent.

Some goods do sit, however, and this can be very lucrative if they become fashionable at a later date. But it can also be costly, for they may turn out to be deadwood. Often it is difficult to liquidate quickly, unless the works of art are so highly sought after that there is a ready market for them at all times. If a private collector purchases a painting and decides after six months that he wants to sell it and enjoy a profit, he might have an unpleasant surprise—the

dealer's commission for selling it. Any profit which may have accrued could well be consumed by this fee, unless the work is very rare and of top-notch quality, or enough time has passed since the initial purchase that the appreciation has outpaced the deductions. Sometimes, markets encounter setbacks and turbulence, so that when a peak price is paid for a work of art, considerable time may be required to overcome the dip in the market. On occasion, you might buy a rare work of art and have an offer providing a good profit almost immediately afterward, but the likelihood of this happening is slim.

Investing in art is generally practiced by those who have sufficient time and money. To do it intelligently, it is wise to engage in a long-term program and to invest with people who have an intimate knowledge of the art market, who have been in the business for a substantial number of years and have a proved track record.

To earn respectable returns on your investment takes time, so be prepared to proceed at a modest pace and don't anticipate overnight wealth. Investing in art is exciting, but it can be treacherous if you put your money in the wrong place. Many of our clients are collectors first, and investors second. They buy with the expectation that even if, at worst, the economy goes sour and their investments dwindle to a state of worthlessness, someday—even if it's five, ten, or fifteen years later—their investments will reach old levels of value, and perhaps even surpass them and produce a proper profit. And in addition all the while they have had in their possession something of beauty which adds a new dimension of pleasure to their lives.

Chapter 6
Risks vs. Rewards and Deals to Avoid

In the world of art trading, there are many opportunities for making big money. But beware! For every legitimate deal there are untold numbers of confidence scams in the wings. Where there is money to be made, there is always unscrupulous greed nearby, and the art market is no exception. It is a perfect breeding ground for a host of sophisticated deceptions which range from the fencing of stolen objects to complex fraudulent investment schemes.

The first pitfall is the dishonest art dealer. Occasionally clients report bad experiences with men in our business: an art dealer who failed to cover a check he had given him, representing the proceeds from the sale of his painting; a dealer who failed to sell a painting consigned to him and yet refused to return it; a dealer who sold a client an expensive painting, neglecting to inform him that it was a fake or had been restored to death, and then closed up shop before the victim could reach his attorney. And so on.

How do you protect yourself from fraudulent dealers? Actually, there are a few safeguards. If you are about to

begin to collect works of art, consult a few local museums for references. You are generally better off dealing with firms that have been in the field for a long time—twenty-five years and more. That doesn't mean that one who has been dealing in art for only five years isn't capable or knowledgeable; it does mean that your odds become more favorable as the dealer's experience grows. When a dealer develops a reputation for illegitimate dealings, the news travels quickly. He becomes a black mark in the industry, and often goes out of business entirely. Bad apples often have a way of being sorted out and disposed of by the public or other members of the trade.

To ensure further that you are dealing with someone reputable, contact the organizations with which he is associated. Also, check into the nature and standing of the organizations themselves and make sure that they still exist.

A good dealer will not try to hard-sell you—he knows that his goods will sell themselves, given the proper exposure. He will also refer you to another dealer if he does not have or cannot get what you want. Frequently, dealers know the whereabouts of many other works of art even though they may not own them. It is common practice for one dealer to take works from another to please a client.

This kind of service can be most beneficial to you in saving steps and time, and it might even save you money. As an example, if you were to visit my gallery in Philadelphia with a request for a substantial-size oil painting by Thomas Moran, and I didn't have one at that moment, I could (if I knew of one) take on consignment,

from a colleague in New York or Texas or California, an appropriate example which might be worth $75,000 retail, but $65,000 to me. I might then offer it to you, if you were a good client, for $70,000. You save $5,000 and find a painting which you might never have known, and I make $5,000 for putting the deal together. The dealer who owned the painting before is happy to move it along and recapture some invested capital.

Sometimes, though, this kind of deal can backfire. If the dealer who takes the picture on approval should raise the retail price considerably, you would have been better off to acquire it from the original dealer. Of course, the price raise may be quite justified, if the initial price was below market or if the example was so rare a find that price was secondary to quality.

As we were sifting through the racks of a colleague one day, we happened across a sizable painting of a European landscape with figures, which was not properly cleaned or framed. It was a masterful work of art, which we were informed was about to go to auction. "How much do you want for this painting?" we inquired.

"I've got to get $3,750 for it," he said.

"We'll take it."

After cleaning and reframing it, we sold it to a client of ours for $12,000 with no hesitation on his part or ours. The point of this anecdote is not to imply that dealers take advantage of their clients, but rather to illustrate that some have a greater ability to recognize quality than others.

Once in a while you'll read about a dealer or broker who perpetrates a fraud of striking proportions. Investors get

involved in works of art that are nonexistent or which are sometimes sold illegally. But the standard investor would most likely never encounter such an unusual circumstance. Dealers are legitimate businessmen who rely on repeat transactions, so that they are anxious to please their clients. One sale should always lead to another. As I mentioned before, the dealer who doesn't perform with satisfaction and integrity will find his way out of the marketplace.

The deal to shy away from is the one which promises an extraordinary return on your investment in a very short time. The broker or dealer who "guarantees" you at least 30 percent a year growth for ten years must be either dishonest or naive. The art markets are always susceptible to fashion changes and currency elevations and declines. There can only be projections and educated guesses as to the future, no wild guarantees. Though an outlandish guarantee *may* materialize, the odds of winning a lottery are better. You should not want anything but a conservative growth plan for long-term investment.

We are constantly questioned about the growth of value in paintings. Typically, "If I buy this painting from you today for twenty-five thousand, what will it be worth in five years?" one client will inquire.

I respond, "There's no real way to tell; time will give us the answer. If inflation continues at its present rate and there is no great surprise, you might expect a doubling or tripling of your investment—but there is no guarantee."

"Well, how about that dealer in New York who's offering twenty-five percent a year on investments and will buy the goods back after ten years?" he inquires.

"Look, if you see something in his gallery that you really love, then buy it—but don't expect to liquidate in a few years and make a fortune. If it happens, that's terrific, but if it doesn't, don't be jolted. The most experienced of us suggest only that the very best quality in any specialized area will remain strong, and will stand an excellent chance for growth. But to predict a specific percentage per year is unreasonable."

There are organizations who will make wild promises and offer you the sky. Take them with a grain of salt—most of them are riding on the coattails of all the recent publicity about art and investment. There's a lot of bad advice available for the naive collector or investor, and again the best way to avoid it is by dealing with the most reliable concerns in the business. By doing so you will not have to worry about the problem of stolen works of art. Reputable galleries wouldn't touch anything questionable—they check out the sellers from whom they make the purchases, if they don't know them. Publications like *Stolen Art Alert* (formerly *Art Theft Archive Newsletter*) are subscribed to by most galleries. *Stolen Art Alert* is published twelve times a year by the R. R. Bowker Company in association with the International Foundation for Art Research. To subscribe, write to R. R. Bowker, 1180 Avenue of the Americas, New York, New York 10036. The current price is $48 per year.

If you are asked to become a partner in an "overnight deal," decline the opportunity. It almost always spells disaster. It usually takes this form: you are offered a unique opportunity to invest in a "fabulous" painting; all you

have to do is turn over your money and sit back for two weeks to one month. You'll get your money back plus a 50 percent profit. You don't need to see the painting or worry about selling it—it's already sold; your money will finance one half the cost of purchase.

The most recent offering of an impossible romance deal made to us was the chance to purchase a painting that was alleged to be a self-portrait by Renoir. Only $2 million. It was a compact 12" x 10" oil on canvas. The purchase had to be made within the week (it was already Wednesday), the agent informed us, or else the client who owned it would take it off the market. After I asked about viewing the painting (just for amusement), the agent declared, "Oh yes, no problem. It's in a vault in Paris, but I can take you to see it after you put up the money. In fact, I was gonna go there this afternoon." You could not fully appreciate the absurdity of this sequence unless you were present during the conversation. The photograph of this painting was a color Xerox; the painting had absolutely nothing to do with Renoir, and even if it were by Renoir, the price had one too many zeroes on it.

When you're representing a painting which is an important work of art, you don't expect a client, with whom you've never dealt and don't even know, to buy it sight unseen. There should be no urgency, coupled with the threat that the work would be withdrawn from the market. The documentation should be absolutely airtight—in this case there was a letter from some so-called expert, hardly adequate for a $2 million purchase.

I told the agent—whom I'd never seen or heard of before—that I wasn't interested in the work. What I didn't tell him was that I didn't like or trust him. The whole deal was wrong from beginning to end. The final insult came when the agent said, "If you don't want to buy it but can sell it to a client at $2,200,000, I'll give you a commission of $50,000."

"Very generous of you"—I smiled ironically—"but I'm afraid I can't help you." That's what we call the "overnight deal," and I can tell you from experience, though it sounds glamorous and exciting, it never works. The paintings either don't exist or they're not as they are represented.

This kind of sham shouldn't deter you, however, from making sizable investments in art. Just be sure you are dealing with a trustworthy firm or individual, that you can see what you are buying, and that you have a written contract drawn by your attorney.

Aside from the risks of "overnight deals," fraudulent dealers, stolen goods, and offerings which dangle promises that seem too good, there is a handful of things to beware of in collecting art.

Certain "investables" may not be as investable as advertised. Everybody is in on the investment kick these days; suddenly anything can be labeled "investment quality." Well, a lot of garbage is being palmed off as "collectible." Sure, by broad definition anything is collectible if somebody decides to collect it, but in the art business there are boundaries as to what is really an investment. Simply because you pay out $10,000 doesn't mean you've got an investable commodity, even though you've made

an investment. The amount of money which you invest could easily have no relation to the quality of the investment. As a rule, the best things are more expensive, but not all of the expensive things are the best.

A legitimate firm cannot afford to counsel you with bad or inaccurate investment advice. Some works are sure things, others are long shots, and some are completely out of the question. Reliable dealers of taste know which items belong in each category, and will advise you appropriately. Unfortunately, there are also many self-pronounced experts in the field who just don't know what they are doing. Generally they sell art as an investment and care nothing about the aesthetics or the emotional responses produced by the interaction of the client with the painting.

Works of art develop their value as an investment mainly as a result of their quality, their rarity, supply and demand, publicity and promotion, and changes in fashion. These elements, which also affect prices, can reduce or eliminate a work's value as an investment as well as create or increase it. Trends change, and so do supply and demand, so that what may be investment at one time may not be at another.

The right kind of art will, in all probability, retain its value as an investment, but how does the purchaser acquire the "right" kind of art? The way to do that is to work with qualified professionals, who know as much as there is to know about dealing in art, and to follow their advice.

Theft is always a hazard to be considered when you are collecting fine art, but not as great for art as for more

prosaic valuables. Art is the most sophisticated of all collectibles and is frequently overlooked when a common house thief, junkie, or burglar breaks into a house. To begin with, most burglars don't have the knowledge to distinguish between valuable paintings and sculptures and reproductions or minimal-quality works. The stolen works would be extremely difficult to fence and would bring the thief under the jurisdiction of the FBI and other law-enforcement agencies. Works of art are not as universally convertible into cash as are coins and jewels. Art thefts are closely followed when they do occur, and the rate of recovery is very high, so that there are many more obstacles for the art thief to overcome than might be imagined. Good collectors keep complete records, including photographs and slides, making it easy to trace and publicize an art theft.

The buying of fakes or forgeries is another risk, but one that can be circumvented, again by dealing with the most reliable art galleries. It is not unusual to find dubious works in the art market surfacing from time to time. Signatures are occasionally tampered with and names are often concocted, which have nothing to do with the actual artist. Misattributions are deliberately attached to works, leading the naive collector to believe that, for instance, because the nameplate says a painting is by Bierstadt, it really is by Bierstadt. Anyone who pleases can order a nameplate with the name of any artist he chooses—there is no correlation between nameplates and authenticity. For some peculiar reason, though, many people accept things at face value merely because

they are in print. Nameplates should not be considered proof of anything.

The final problem you want to avoid is art riddled with hidden areas of restoration. If you do not know how to detect and interpret the various types and degrees of restoration, and you are buying at auction, you might be surprised with the true condition of your acquisition. It may be in fine state, but it might also be in very poor condition. It would make sense to take an expert in restoration along with you or refrain from bidding if you have the slightest reason to doubt the work. Restorations can be masked by use of certain varnishes and paints, and all but the experienced might be deceived. Again, though, if you deal through galleries with proved reputations, restorations will be shown to you upon request, and if something is very highly restored and you are still not discouraged, you might even negotiate a concession in the price.

Despite all the precautions in this chapter, one should not give up thoughts of collecting fine art. The rewards of judicious, careful investment far outweigh the risks. Your success will be contingent upon the degree and quality of your experience, and quality, knowledge, and reliability of the people through whom you work.

The greatest gain in collecting art is the pleasure involved. Placing works of art in your home or office can be a very enriching experience. Your space will come to life with the addition of this new dimension. Whether your choice is oil painting, sculpture, drawings, or objects, your surroundings will be visually enriched, making you wonder how you ever found complete satisfaction

without them. New vibrant color brightens what might before have been the rather bland surroundings of empty plaster—or paper-covered walls. Art can be of historical interest, taking you through bygone eras, providing a bridge to any century of recorded history and the lifestyle that was associated with it. Reading history books offers you imaginative glimpses, but the artists' renditions bring the scenes concretely before you, your family, your guests, and visitors. You can achieve a unique thrill from works of art.

I'll always remember the feeling of peering over the jagged edge of a section of the Grand Canyon—looking down almost one mile into what seemed like a bottomless pit, where there flourished a scarcely discernible Indian civilization. I was thirteen years old then. The awesome feeling remained with me ever since. Years later I was fortunate enough to be in the Museum of Modern Art to view an exhibition of American paintings, and there in front of me was Thomas Moran's large-scale painting of the Grand Canyon. It clouded everything else I had seen in American painting. It was as if I were standing at the edge of the Canyon itself, stunned by the array of color and the haunting ruggedness. Looking into the depths of this painting inspired the same awesome feeling as my experience with the actual Canyon. I stood there transfixed for twenty minutes— absolutely unable and unwilling to draw myself away from this massive painted view of one of our world's wonders. The feeling was so majestic and so extraordinarily powerful that I was convinced Moran must have felt the same excitement and disbelief

which had overwhelmed me. What a master he was to have been able to capture the true sense of perspective of the Grand Canyon and to portray it so accurately and emotionally with his brush and interpretation of color.

When I am asked what type of paintings I personally collect, my response is, "Whatever I see that says something to me, that evokes a response of pleasure or that intrigues me. My own collection is of soft impressionistic images with harmonious colors that blend with rather than interfere with my environment. After a bustling nonstop day of complications and problems, I seek serenity and peace. I can achieve this in part by the type of art I include in my home."

If one seeks status, an art collection can be one of the best means. A well-put-together collection with the right names and the right examples can be most impressive not only to those who value material possessions, but also to those who appreciate the aesthetics of fine art. Generally, however, those obnoxious people who acquire art for the express purpose of creating status collect loud, flashy types of art. They don't have the taste to collect the best, because they are unaware of it and unable to discriminate what is good from what is bad. They do not realize that the simplest and most striking images are far superior to the cluttered overdone works. They're dedicated to the notion that more is better, not concise is powerful. Since there are so many graduates of the school of bad taste, those who refuse guidance or professional advice can assemble quite atrocious collections.

That isn't to say that status associated with bona-fide well-selected collections doesn't exist; it definitely does, and should be treated with due respect. It's just that fine collections are sometimes overshadowed or downgraded by the others, and their status is shared equally in the eyes of those who don't know. A truly fine and important collection of art deserves both admiration and honor. It is something of which to be very proud—especially if you've hand-picked it from the beginning, for then it reflects your good taste. That in itself merits admiration. It's like any other endeavor; when done properly, it aims at success. When success is achieved, recognition follows.

Collections of art have another advantage; they require little maintenance. Art is generally very enduring, the more so if there is no human interference. If left alone with a minimum of care, art objects do well for many years. Oil paintings may contain pigments which dry after considerable time, because of the medium used or the way it was applied, and may therefore produce craquelure, a spider-web type of cracking in the paint, which gives character to the work. It also substantiates the age of the work, since it takes many years (usually five to ten years minimum and generally twenty to thirty) before you'll even notice it. Varnishes are also susceptible to craquelure of their own after some time (how long depends on type of varnish, application method, and quantity). Paintings, watercolors, drawings, and furniture should not be exposed to extreme heat or cold. They should also not be subjected to continual humidity changes. Higher humidity levels are more tolerable than dryness, but too much dampness will cause

warpage in furniture and in panels of oil paintings. Too little moisture in the air may speed drying of pigments and cause flaking of paint. Too much direct sunlight will cause instability of oil paintings, sculptures, and furniture.

Picture lights hung directly over oil paintings may in time endanger the stability of relinings and cause them to buckle from the heat. You will do much better to install track or spot lighting from your ceiling.

Fireplaces (not protected by a mantel) can cause terrible damage to oil paintings suspended above them, because of the upward flow of heat and smoke onto the canvas. Sprinkler systems, though lifesaving in purpose, can cause irreparable water destruction to paintings and furniture if they accidentally or necessarily perform their function. Water penetrates and stains as well as alters chemical composition, so try to place your art to avoid the radius of exposure of any of these potential hazards.

When you own a collection of fine art, there is an advantage you won't find in other investments such as real estate: there is no tax to pay while it appreciates. Of course there is no depreciation write-off, but nobody buys art for depreciation. No matter how the value of your investments grows, you are not penalized by any federal, state, or local taxes. Of course, when you sell it, you might find yourself in a tangle of taxes, but check on that in the chapter dealing with tax benefits.

Art can appreciate—depending on the behavior of all of the factors which influence prices—like no other investment. We've seen items in our own inventory double, triple, and quadruple in value in less than ten years.

Given that you acquire works with the right growth potential, and provided that the other factors are all in line, you have an excellent chance to make some real money. Works of art that demonstrate solid growth, both proved and potential, are often used as collateral by private and public institutions such as major banks, but the quality must be present. On many occasions we've put up as collateral a group of paintings in negotiating a major investment that would take six months to one year to begin to show a profit. In one instance, the bankers knew that they were secured adequately in the event a $2.5 million venture failed. We knew the venture could be nothing short of a smashing success, and therefore our paintings, which were at risk, would be returned to their home safely. Meanwhile, it turned out that we were delighted that these "secured" paintings were off the market, for in that one year their value nearly doubled. Of course, the bankers with whom we were dealing were familiar with the logistics of the art market, and, needless to say, knew the quality of our paintings. Bankers, as a rule, are rather conservative, so don't expect to have your works of art accepted as collateral unless they are top quality and unless the risks of the deal they are guaranteeing are minimal.

The appreciation potential of fine art is universally recognized by collectors, as evidenced by the thousands of galleries and dealers who capitalize on it. It is this potential that assures the survival of the industry.

Chapter 7
The Auction

As I've stated earlier, an auction is a hair-raising experience, best confronted by the veteran, and best attended with restraint by everyone else. There are both exciting opportunities and fearful pitfalls in the auction arena—definitely an arena in every sense. The competition is fierce and yields only to the highest bidder. There is no regard for reason and no courtesy except for the power of money, which is plentiful, seemingly in endless supply. Money is matched only by egos, swollen to capacity, and undaunted by reality.

This is the background for the financial psychological warfare known as the auction. One can only marvel at the bravery and sometimes outright stupidity displayed by the contestants. Incidents of such behavior never fail to occur and never fail to astonish the more temperate.

In exploring the auction, we'll first view the positive aspects, which are fewer and less complicated. From the vantage point of the buyer, the major auction houses in America are Sotheby Parke Bernet (New York and Los Angeles), Christie's (New York), Phillips (New York),

William Doyle (New York), Plaza (New York), Samuel T. Freeman (Philadelphia), Robert W. Skinner (Boston), Robert Eldred Co. (East Dennis, Massachusetts), Richard Bourne (Hyannis, Massachusetts), Sloan's (Washington, D.C.), Weschler (Washington, D.C.), Butterfield & Butterfield (San Francisco), Barridoff (Portland, Maine), Mortons (New Orleans), and Dumouchelle's (Detroit, Michigan).

These houses offer a huge selection of paintings, watercolors, drawings, and sculptures as well as antiquities, and other collectibles, steadily and frequently. A distinct advantage is that the quantity of available goods is substantial. Most auction houses also offer a catalog for each sale, listing paintings, watercolors, drawings, and sculptures, giving sizes, mediums, provenances (if any exist), and price estimates. It is worthwhile to purchase the catalogs, which aren't too expensive and supply some very helpful information.

If you attend an auction and are a discerning buyer, you might be pleasantly surprised to find "sleepers." Very often treasures can be found if you know more than the next fellow. You shouldn't count yourself out of the competition because of the dealers lurking about. They too can overlook a desirable item because their attention is focused elsewhere. Works they consider out of the mainstream may sell for fairly low prices at auction. Even though such items are beautiful and of excellent quality, if they are not highly sought after, they become real bargains.

If you are thinking of selling some of your art at auction, the following favorable points should be noted. If

you are dealing with an auction house in a major city, you will benefit by the wide publicity and exposure in newspapers, in art journals, and in the sales catalogs. The audience is generally overflowing. People are fascinated with auctions, believing that they can make a killing. Even though this happens very rarely, it *does* happen. The interest and the customers are there, so the odds are favorable that your items will find their way into the hands of a buyer.

Dealer attendance is another plus for those who sell through auction. At any auction, there will be dealers, either to buy or to protect their own goods. Frequently you can make contact with dealers you might never be able to locate otherwise. Some dealers maintain a "private" status, remaining out of public circulation, but they do appear at auctions. Most will be happy to make your acquaintance, in hopes that it will lead to future dealings, but be prepared for some to be brusque and evasive. There are those who deal only at wholesale level and don't want to be bothered by retail clients. The point is that dealers are present and that collectively they probably have the greatest purchasing power at the auctions.

The final advantage in selling through auction is that some paintings, drawings, watercolors, and sculptures that would be deadwood in a dealer's gallery will do very well there. It is strange how some works do quite well in auction sales and yet for some reason go begging anywhere else. In some cases "auction fever" overrides common sense. People are swept away, going beyond realistic boundaries, sometimes with no better reason than having

their names attached to record high prices. If you are lucky enough to encounter such eager beavers, you may reap some unexpected profit.

Now let us consider the negative realities of the auction game. Let us first take the buyer's point of view.

The buyer enters the salesroom in plenty of time to find a strategically located seat—far enough back in the room so that he can see all of the bidding. There are five lots for which he is prepared to pay handsomely. The first hour of bidding is very spirited. Nerves are taut and palms are sweaty. Our buyer's first item is coming up. The estimates suggest $10,000 to $15,000 for this very pretty small landscape by Jasper Cropsey, who was a prominent member of the Hudson River School of painting. This particular work looks as fresh as the day it was painted, though it didn't look quite that spectacular in the exhibition room two days ago. Couldn't be the three 150-watt spotlights, could it?

Well, $15,000 is bid in a matter of seconds, final bid $26,000. The estimate was $15,000—what happened? Nothing unusual! Estimates are just that—guesses, supposedly educated, based mainly on historical data with little thought for particular circumstances or bidders. Remember, sales catalogs go to bed about two or three months before the sale, and lots can change in that time. Trends can come, go, diminish, or amplify during that period. Currencies can fluctuate and affect values. Inflationary pressures can bring a host of new investors into the auction. Presale estimates are usually out of date by the time the sale day arrives. It has also been rumored

that they are kept slightly low to lure buyers to the sale. After all, if the estimates seem too high, many collectors won't even bother to attend, and the auction houses can't afford to let that happen. Pessimism is deadly in the auction business.

The second item on our buyer's acquisition list is about to be offered. The estimate is $40,000 to $60,000. The painting is by Childe Hassam, a much-sought-after American Impressionist painter of the late nineteenth-early twentieth century. This painting is a gem, a small oil (16" x 12") depicting a Parisian street scene with a lady walking under an umbrella. With momentum already generated, the estimate is expected to be inadequate. Sure enough, the hammer bid is $97,500, and everyone begins to applaud, except our buyer who's completely dumbfounded. The painting was bought by a private collector. He not only wanted this picture with a passion, he couldn't bear the thought of anyone else owning "his" painting. He would have paid any price to secure it. People like that do exist, and there are more of them around (with seemingly unlimited funds) than you might want to believe. They can ruin your day at the auction.

The same thing can happen when people get struck by "auction fever"—that phenomenon which distorts reality, appealing to people's egos to enter frenzied bidding contests.

The highest price gathers the most attention, making the successful bidder, otherwise an ordinary person, a hero. The other component which fuels auction fever is the thought *What the hell, it's only another twenty-five*

hundred. Many bidders don't stop with just one increase over their predetermined limit. Somehow they lose sight of their original intentions and get swept away by the emotional need to bring home the prize. If it's worth more to someone else, it's worth more to them too, regardless of the intrinsic value.

The energy in an active salesroom is very exciting— powerful and supportive. It urges you to keep going; it almost dares you, threatening you with failure and cowardice if you quit. It can get you in trouble if you fear that circumstances are conspiring with your competition to make you forfeit your purchase. Auction fever can shatter your hopes of buying an item in demand at auction. It's like a super competition that yields to no one.

Hidden costs don't generally pertain to auction buying, but some houses like Parke Bernet, Christie's, Phillips, Doyle, and Skinner, charge the buyer a 10 percent premium on all purchases. If you've bid $25,000 in the final bid, be prepared to lay down a check for $27,500 when you pick up the item. People often forget about the additional 10 percent, but it definitely must be figured in the purchase price. Most times it's not too great a factor, but should you have a limit, 10 percent more can make the deal impossible. If something seemed like a bargain before, the 10 percent difference might even up the score and could even mean an overpayment.

Auction houses want their money as quickly as possible so that they can pay their consignors, who know that they must wait until their goods are paid for by the purchaser. Don't expect that you'll be able to take your purchases

home without paying for them first. After all, once the item is in your possession, the auction house would have a most difficult time retrieving it if you were to default on payment. Of course there are exceptions. The steady buyers with large accounts are given courtesies, but these dealers and collectors are not considered a risk. They're well known, well respected, and well off financially.

Our buyer, who is rather disheartened by this time, is about to receive another negative jolt from still one more group at the auction—the dealers. The third painting on his list of wanted acquisitions is also on the list of a dealer syndicate, which has been formed to avoid competition among the dealers themselves. The group of four dealers have decided to pool their resources and work together, thereby eliminating the major potential threat—their own bidding. They can also afford a much steeper price this way because they will divide the final purchase price by four. They'll have only one quarter of the profit to share, but that's better than losing the whole deal to a private collector.

This time our buyer is outraged enough to do something stupid, and he has enough money available because of the two unconsummated purchases. He has more than enough capital to cover the $80,000 to $120,000 estimate for the third choice on his list. The bidding begins, and in accordance with intelligent procedure our buyer lets someone else open the bidding. He jumps in at $50,000; the dealer syndicate comes in at $75,000. He's still in at $95,000. The next bid tops $100,000 and the increments are stepped up by $10,000 a bid. Now the bid is $130,000

on the other side of the room, $150,000 on the phone. Our buyer gives it his best at $190,000, only to be shattered by $220,000 from the front row, the dealer syndicate. Once the syndicate has determined to acquire an item, there is no way to overcome them. A hazard in the auction room, they are a factor you can expect to encounter at auctions. As I mentioned before, dealers appear in large numbers at the auctions, too, which provide a marketplace for them.

It is not uncommon for a dealer to bid on behalf of a favored client for a small percent of the purchase price (1–10 percent). If this occurs and the dealer's client is willing to stretch for a painting or piece of sculpture which you want to buy, watch out. You're up against insurmountable odds again.

If you're new at the game or experienced in bidding but not in interpreting restorations, you have a very serious problem. Auction houses do not comment about or guarantee the condition of the goods they are selling. Lots of paintings look too good to be true, and given the age of some, they probably *are* too good to be true. Many works are in excellent condition or very fine condition, but it takes a trained eye to be able to distinguish between irreparable restoration and unnecessary restorations that can be undone and corrected. Often, incompetent restorers will overpaint massive sections of a painting rather than simply repair the small area that is damaged. Just as often, though, massive restorations are necessary and cannot be corrected. If you buy the latter and pay a big price, you can lose a good deal when you go to sell it. The buyer may have a sharp eye for restorations. At auctions there are a great

many paintings in medium-to-wretched condition, as well as those in very fine condition. Beware, because what you are buying may not be what you think you are buying. It would pay to take an experienced adviser with you, perhaps a dealer who knows restoration (there are very few) or a professional restorer who knows (there are even fewer of them who *really* know). Exercise caution before you pay out any large sum of money at an auction. It's a great place for dealers to consign goods that won't sell elsewhere. The auction is sometimes known as a dealer's dumping ground, and though you can frequently buy a dealer's goods at greatly reduced prices, you might wind up with goods that were impossible for him to sell, and that will not be easily resold by you. Dealers frequently put their "mistakes'" into auction—items for which they've overpaid, items for which they have no market, or items they won't sell directly to good clients to whom they feel responsible and accountable. When you buy art from a reputable dealer, if there are any complaints or deceptions, they can usually be satisfied quickly and without difficulty.

Though generally not practiced at the larger auction houses, false bidding by the auction staff to boost prices is not uncommon in some of the smaller outfits. Shills or "house plants" who bid for nonexistent clients or who act as clients themselves are an unethical lot, working for houses who are interested only in making large profits rather than in maintaining integrity. There isn't much you can do to prevent this kind of activity except to bid to a specific cutoff point and, if the bidding bypasses you, forget the item.

Occasionally art items, whether paintings, watercolors, drawings, or sculptures, are sold for dramatic prices at auction and may later be deemed "incorrect"—that is, they are not what they were purported to be. Recourse depends on which auction house you are dealing with, and the terms of the sale relating to authenticity. Most country auctions make no such claims—you are completely dependent on your own judgment. If you buy wrong, it's your own fault. You cannot lay the blame or responsibility on the auctioneer or anyone else, and it would be most unlikely for your money to be returned. The larger houses like Sotheby Parke Bernet, Christie's, and Phillips make specific reference to authorship and guarantee in their catalogs, and frequently draw verbal attention to this point before the sale commences. They have occasionally made incorrect attributions, but these were honest errors, not misrepresentation, and no one gets hurt.

If you recall, our buyer at the sale missed three paintings he wanted to buy. The next two works on his list had another fate—they were withdrawn prior to the sale. No reason was given but there could be several explanations.

The consignors may have changed their minds; there may have been confusion over title or ownership (auction houses don't want to get in the middle of that dispute), or there may have been some dispute over authenticity. Withdrawal of goods is infrequent, but it does occur now and then. Just another of the obstacles in buying art at auction.

Now let us discuss the adverse conditions that you may face when you are the seller of goods in the auction.

Different houses specify different periods regarding the time between submission of contracts for the consignment of goods and the time the goods are actually sold. This period, depending upon the number of items in any given sale, the complexity of the catalog, and the frequency of sales, can range from a few weeks for the smallest, least sophisticated sales, to a few months for the best and most interesting sales. The interim between the actual sale date and the payment to the consignor can vary from about one week to thirty-five days. All told, your goods may be tied up for as much as three to four months. You cannot try to sell your goods during that time, for you've signed them over by contract to the auction house. They can be withdrawn, but stiff financial penalties may be assessed (up to 20 percent of the reserve price), which you are obligated to pay. If you make a habit of consigning goods and then withdrawing them in advance of the sale, the auction houses will no longer deal with you; and why should they? They make announcements, undertake expense, and then you reverse yourself, disappointing both the auction house and their clients.

Let us say that your property is contracted in February for a sale in May. The sale date arrives, and the items which are yours have predetermined "reserves" on them. That means that if your reserve price isn't met by the bidders, then the auctioneer cannot sell your item. This is a safeguard which is designed to protect your interest, but which can also backfire unexpectedly. Let's suppose you have two paintings in a sale. They each show estimates

of $10,000 to $15,000, with reserve prices of $7,500 and $10,000 respectively.

On the day of the sale there is a severe storm, cutting the number of customers to a handful. Not only that, the major banks in New York announce another in a series of increases in the prime lending rate. That alone eliminates another 20 percent of the audience who might have been interested in your works. As a result, the two paintings don't sell—they've each missed the reserves by $2,000. Now you have to pay 5 percent of the reserve prices ($875) to the house. Statement of account: you are out of pocket $875; two paintings have been tied up for several months; now the paintings have a stigma attached to them: they went through the auction and failed to sell! The first question any potential purchaser will ask is, "Why?" Abnormal weather and a soaring prime rate sound like lame excuses, not convincing to a veteran dealer in this business. He knows that foul weather wouldn't have stopped him, and that the prime wouldn't affect 80 percent of the art market. There must be something wrong with the pictures since no one made a serious offer for them. Right or wrong, this is the conclusion that is drawn when art fails to sell at an auction. The remaining taint is long lasting and difficult to eradicate.

Another reason your painting may not sell at the anticipated price, or at all, is that it was placed in a poor sale. There are sales in which a great many items are of spectacular quality, and then there are sales in which the best item may be no more than mediocre. If your paintings are placed in one of the latter, they have much less chance of

bringing a proper return, for there will be unenthusiastic attendance. In such an atmosphere there is little hope of seeing bidding competitive enough to raise prices to an acceptable level.

Auction houses may withdraw your property before the sale. That is a right they reserve, and for which they need offer no explanation. The auctioneer also has the authority to withdraw any lot he feels is not attracting sufficient bidding, or which he feels is being bid up by the consignor. If there is to be any bidding up, the auction house, not the consignor, is the one to do it. If your property is withdrawn, you'll probably have to pay some minimum expenses incurred by the house. If you leave anything there for a prolonged time after the sale (or failure to sell), you will be charged storage and perhaps cartage and insurance.

When you consign property to the major auction houses, expect to pay a 10 percent commission upon the sale of the work (they deduct all expenses up front from the payment). Christie's, Sotheby Parke Bernet, Phillips, Skinner, and Doyle all take 10 percent from the seller and charge an additional 10 percent to the buyer. Some auction houses still charge a traditional 20 percent to the seller with no tithe from the buyer. More and more, though, the burden of the commission is being shared equally between buyer and seller.

When you are selling, you can also anticipate fees for catalog illustrations, insurance, cartage, and perhaps publicity and storage. Although those fees are modest, they still cannot be ignored.

If your property is sold, there is always the possibility that the buyer will renege, and then you will have three options from which to choose. You may of course take possession of your painting, reenter it in another upcoming sale at the discretion of the auction house, or you may be able to have them sell it for you privately. For a buyer to renege is most unlikely, but in the event of financial distress it may happen.

Currency fluctuation can have a dampening effect on sales. If you have, for instance, a Dutch nineteenth-century painting entered in a sale, and the Dutch dealers, who would normally spend big money, have currency devaluation at home, or have satisfied their markets temporarily, or have had an import tax of 20 to 30 percent imposed upon them, they will either spend far less money for acquisitions or bow out of the competition altogether.

Recently the Japanese, who had been very strong buyers at American auctions, virtually abandoned the art market here because of the severe rise in the cost of oil in their own country. If you are surrounded by such financial complications, your goods must inevitably feel the effects.

Dealer syndicates can undermine your plans for spending the munificent proceeds from the sale of your art at auction. It's very convenient for a group of dealers to form a cooperative organization to buy certain goods for the lowest possible prices, and then to resell them among themselves later in a private auction known as a "knockout." This avoids commissions and competition by private collectors. This dealer cooperative won't injure you, though, if private collectors are well represented at

the auction, and if your goods aren't exclusively sought after by the dealers. In today's art market, private collectors are good competition for dealers, and their bidding can effectively fend off dealer combinations. Dealers have to resell their goods at a profit while private collectors are rarely interested in liquidating items they've just acquired.

Auction houses themselves have also been known to buy items in a sale. If the bidding on some items is too low, the house might make the acquisition with the intention of reselling them for more money in a later sale or by offering them to one of their private clients. The same practice holds true in the selling of art owned by the auction house. It would seem that there is a conflict of interest in such activity. The auction should be unbiased, in theory at least, conducted for the benefit of the audience, not the auction house. This is by no means a condemnation of the auction business, rather a question of whether or not it is good policy for an organization with a neutral status to step into the arena. If auction houses are going to become dealers, they should make that clear to their public, and not perform surreptitiously.

It has also been a practice of some auction houses to knock goods down to favored clients, which implies that the auctioneer exercises a bit more discretion than should be permissible. He gets a little sluggish, toning the bidding to his pace. If the offered item is not evoking fast and furious bidding, the auctioneer can more or less control it, or engineer it so that his client is the successful bidder.

The auctioneer is instrumental in achieving a successful sale. He can help inspire higher prices by his dynamic appeal to the audience or he can reduce the bidding if he appears bored. Top-flight merchandise, however, will always take care of itself, no matter how the auctioneer conducts himself. Items that are not prime quality do give the auctioneer plenty of opportunity to manipulate the bidding to benefit his special clients.

One final word of caution about selling paintings, drawings, watercolors, and sculptures at auction: careless handling can do irreparable damage to the items. I have examined paintings at an auction house prior to the sale, and I have seen the auctioneer's numbers pasted on the front of oil paintings, not the frames, and I have even seen damage done to paintings such as tears and holes in the canvas. Paintings are stacked without thought so that the hooks and wires make indentations and tears in the paintings behind them. I've seen fine antique furnishings scratched and kicked because they were improperly displayed. The treatment is absolutely shoddy, and there is no excuse for it. Frames are nicked and worse, corners are destroyed, varnishes are scratched, and similar abuses are frequent. The behind-the-scenes people who handle the art have never been taught to exercise care. They must realize that there is a difference in unpacking and handling cans of soup and delicate works of art.

Even though this appraisal of the auction scene is rather pessimistic, I must declare that the auction business is an exciting one. If you exercise proper care, control,

and judgment, you can find many splendid opportunities to acquire beautiful works of art through the auction route. At appropriate times, for the proper goods, it is the ideal means to sell your art profitably. But at all times and with all art, remember the negative factors and exercise caution—you'll never regret that.

Chapter 8
Provenances, Signatures, and Restorations

Historical documentation, which records ownership, ex-collections, and the previous whereabouts of a work of art, is what is commonly referred to as a provenance. It is supposed to include (in theory at least) every collector's name, location, and a date of purchase and sale in each collection, every museum collection which owned or exhibited the object, with the names and dates of the exhibitions. If the object was specially mentioned, illustrated, or cataloged in a text or monograph on the artist, this specific information should be included as well.

It is reasonable to expect that a complete provenance will be available to you when you buy a painting, drawing, watercolor, or sculpture, especially when you buy one in a high price bracket. The degree of completeness will vary for many reasons. Paintings and other works of art usually change hands frequently over a period of several decades or centuries. It is virtually impossible to keep an accurate listing of all the transactions through the years, for the simple reason that many of them are intentionally unrecorded.

We've handled some outstanding paintings from collections of distinction, unrecorded for thirty or forty years. Failure to record does not necessarily indicate any deception; rather, one might consider it like a missing piece of a complicated puzzle. When a painting is known to have been in a designated collection from 1875 to 1910 and in another from 1910 to 1925, but cannot be traced from 1925 to 1955, and then appears in another collection from 1955 to 1979, it may be determined that the unrecorded years were either a result of unrelinquished or lost information.

Occasionally by very concentrated research some of these gaps can be filled, but the validity of the findings depends on the reliability of the sources and on the present status of the names listed in the provenance. If many years have passed, you can expect that certain names will have become untraceable because of death and the absence of heirs or relocation of the owner with no forwarding address. It is also possible that one or more names in a given provenance are invalid—that is to say, names are listed that never had any affiliation with the painting. The names could have been simply invented and the same for corresponding dates, or the names could be those of collectors who did in fact exist but who never had any connection with the item. Fakery is easy. Names can be manufactured so that they are credible and untraceable. Your best protection from such practices is reliance on dealers or auction houses with untarnished reputations.

Entries in literature (reference books, exhibition catalogs, monographs, etc.) are much more easily checked for

validity, though there are some snags which are discussed in the chapter entitled "Risks vs. Rewards."

Today's serious collectors of fine art have become vitally interested in provenances. They provide validity, status, and the necessary documentation for the resale of the work. It is considerably easier to sell a painting with an ironclad provenance than one with a sketchy history. There is no need for explanations, and in a fashion the painting sells itself. The longer the provenance the better, and the more prestigious the names, the easier it is to sell or resell the work.

Labels from fine galleries, museum collections, and private collections are great assets. Though there have been instances of label fakery, this is unlikely, and so long as you are dealing with houses of the finest reputations, who stand behind their goods, you needn't worry. Labels are impressive because they imply that the collector thought enough of the work to put his own name on it, and accordingly if you were familiar with the collector's name (e.g., Rockefeller), you would also be impressed by his reputation. You might also be discouraged if a label or a name in a provenance isn't so distinguished, for example, the name of a dealer or collector who dealt in mediocre art, or in collections which repeatedly contained fakes. However, there are circumstances that could lead to erroneous conclusions. Some collectors with very fine reputations for quality and good taste may have been influenced by bad advice, or they may have been naive enough to be deceived in the very early stages of their collecting.

Provenances may not always prove to be reliable documents, because they are not the final word. Even though they may be factual, confirm the creator of the work, and supply intriguing historical data, they do not establish quality or condition, and they are not essential in transacting many sales.

It is common for works of art to be handed down to members of a family through the generations, and for the prior whereabouts of these works to have been unrecorded, forgotten, confused, lost, or altogether unknown. That type of provenance will then merely consist of the words "Private Collection." Such a provenance does not reduce the quality of the work, but only suggests that there is not very much information available.

The painting entitled "Trooper of the Plains" by Frederic Remington, which I discuss in the chapter "What Influences Prices?" came to us from a private collection. There was no prior provenance; the painting hadn't been known in the art trade for generations and even the excited experts on the work of Remington were unfamiliar with it. The lack of extensive information made absolutely no difference in the quality or in the price of the painting. We, as art dealers, were ecstatic about the discovery and acquisition of such an incredible painting. We knew that the picture was authentic and that it came from a very fine private collection. The fact that it hadn't been exhibited and hadn't been included in any texts or catalogs didn't matter. The quality was there and that was our foremost concern.

Provenances may not be critical when one collects fine art; circumstances, the quality of the art, the firm that

offers it, and other incidental information determine how vital the provenance may be.

An element that promotes even greater controversy is signatures. To preface this topic of distorted notions, I must first inform you that not all artists sign their work, and those who do may not sign all of them. An artist may not sign a painting because he is more interested in achieving his technical goals, or perhaps he thought it just wasn't important that he sign the work. Signatures are frequently omitted because they can detract from the aesthetics of the work. You need not be surprised when you happen across works of art that are unsigned. They exist in substantial number. The question remains as to whether or not there is a provenance. If not, it may be difficult to prove that the work is what it is purported to be. "Attributed" works which show up at auctions or art galleries, and are unsigned and carry no provenance, are at best a speculation and should be bought only for decoration or for enjoyment. They should not be bought as an investment for resale with the fantasy that they will suddenly become more than an attribution and will bring a huge profit. The odds are very much against you, even though there have been some examples in which names were attached to anonymous attributions with a degree of accuracy. Many of the "Old Master" paintings of the Renaissance period through the seventeenth century bear no signatures or monograms, but authorship has been pinpointed by style. The consistency in work of certain artists becomes a trademark, so that when you've seen a fair number of them you can distinguish them from any

other artist's work. The difficulty comes when an artist's work is closely similar to the work of more artists and the differences are difficult to find. A monogram or signature would be of infinite benefit in such a situation. There are many experts who specialize in the works of particular artists, and I will tell you more about them in the chapter entitled "Fakes and Experts."

When a painting is unsigned but is presented with a complete provenance, or a provenance that is absolutely valid (though it might be short), there is no risk, provided that you are dealing with reputable firms. The existence of a top-notch provenance is more valuable than a signature. We recently purchased an outstanding oil painting entitled "The Grove" by Maurice Prendergast for a very large sum. The canvas size was 15" x 20", and the work was executed circa 1915. The colors were soft yet vibrant; the figures were large and were in the foreground rather than in the distance (which is very desirable), and the painting was signed; but strangely the artist's name was misspelled! It was spelled Prendergat, the "s" omitted. Upon seeing the painting the very first time, I was overwhelmed by its elegance and strength; the quality was unequaled by any that I had seen on the market in many months.

My eyes immediately dropped to the signature, which rang a discordant note in my unconscious. For a split second I couldn't understand what it was that was missing, and then I recognized the faulty spelling. My first reaction was one of disbelief that an artist of Prendergast's extraordinary skill and talent could be guilty of incorrectly spelling his own name. As it turns out, this was not

an uncommon occurrence. We have since seen and have been informed of other examples of his work in which he did precisely the same thing. We have incidentally *heard* his name mispronounced by collectors for years. People insist for some strange reason on calling him Pendergast, Pendergrass, Prendergrass, and Pendergass. A very trying name for some to use correctly, perhaps including the artist himself.

This painting ("The Grove") had been in a very fine private collection since it was sold by the artist's dealer (Kraushaar Galleries, New York City) in the late teens. Kraushaar's label was intact on the reverse of the canvas, mounted neatly on the stretcher and yellowed with age. That in itself would have sufficed, whether or not the painting were signed (properly or otherwise). Our initial fear was that a collector who was unfamiliar with Prendergast's misspelling would have been leery of a misspelled signature. Our fear was unfounded.

Alteration and redrafting of signatures is a grossly offensive, commonplace practice. There are too many people whose warped ethics will permit them to stoop to any level of degradation for money. They will use solvents to remove a minor name from a canvas and in its stead substitute a more sought-after name, which will net them more money. Signatures which do not belong on a painting are usually put there by amateurs, and are generally very obviously incorrect. They are not contemporary with the painting and usually appear to "float" several layers above the painting itself. Often there are layers of varnish on top of the painting, and sometimes an artist would

employ a varnish medium whereby he would paint one layer of the work and continue to repeat this technique after each level was dry, so that by the time the painting was finished there would be several individual levels of paint. The overall appearance is one of depth perspective, where a three-dimensional effect is produced. In that regard, a signature which would have been applied much later would very likely appear to rest on top of the work rather than be an integral part of the structure. If you are unsure about the placement and legitimacy of a signature, take the work to a reputable dealer in the specific field for examination. A sophisticated blend of experience and technical knowledge is required to resolve this problem.

A painting can be correct and still have an incorrect signature on it. Improper restoration can remove part or all of an old signature (if solvents are too harsh or totally inappropriate), and if the restorer is so inept at his trade, he will in all probability add a new signature. That kind of act is generally only an attempt to correct the first mistake he made.

There have been cases where signatures of artists who were not particularly sought after have been covered up with new more popular names, but often the original name becomes much more valuable than the fictitious creation because of a shift in trends.

Signatures without provenances to support them can be quite valid, but again if you are unqualified to hazard a guess and you are unfamiliar with the artist's work, consult a gallery that is well acquainted with work of that type. As I indicated, signatures can be altered or created,

so that if there is no other substantiating documentation about the painting, use the greatest caution.

It is not unheard of that an artist paint, draw, or sculpt a work and sign it thirty years later. This is quite legitimate so long as the artist signs it himself, not a forger.

The question arises concerning estate stamps. These are stamps which are frequently made by galleries that own or represent the estate of an artist's work. The estate stamp mentions the artist's name and the gallery name, and includes the number of the painting in the estate or inventory of the gallery. It is intended to identify the work as part of the estate, and it can be further investigated for specific details by telephoning the gallery whose name is on the stamp. An estate stamp on a work of art provides a feeling of security. It alleviates the queasy feeling sometimes experienced by collectors when they buy an unsigned work of art. They can be assured of authenticity by knowing that their work came from the body of the artist's oeuvre. Obviously, the ideal combination is that of a genuine signature, a complete provenance, and an estate stamp. This is a rare, though not unheard of, combination. Your best assurance is in dealing with the proper people, those who have been around long enough to have gathered the greatest experience, and those who have earned the finest reputations.

The art of restoration needs desperately to be explored at length. It has been abused, mistaken, and grossly misunderstood. To restore is to put something into good condition, comparable to the original condition that the

object was in before it was cut, chipped, worn, burned, abraded, poked, gouged, or otherwise damaged.

Restoration, or conservation as we call it, is a very delicate procedure, which utilizes a harmonious welding of art and science. The scientific aspect refers to the specific selection of solvents, techniques, and materials. The art lies in the application of these scientific components—knowing how far to go to final resolution, perceiving exactly what needs to be done and what shouldn't be done, and then proceeding to do just that and no more.

Conservation can be as simple as removing the old yellowed varnish from a canvas, lightly cleaning the surface of the painting, and then revarnishing it with a synthetic varnish that won't discolor. The natural resin varnishes which were used before World War II tended to yellow with time and give a "golden glow" to paintings. Many older paintings were thought to have been painted with dark golden brown tones. The fact is that they were not as dark as supposed; the varnishes had yellowed and created a golden-brown effect. The function of varnish is to protect the surface of the paint, enhance the depth perspective, and heighten the colors. Older paintings come to life when the muddy brown cast is removed and a crisp clear synthetic varnish is applied. All varnishes should be easily removable in the event of future restorations.

What I've just described is the simplest and safest aspect of restoration. The complexities come with the cleaning, relining, and inpainting of paintings. To clean a painting properly it is critical that the conservator determine what will clean and to what extent. It is imperative that he use

the correct solvents to initiate the action, and that he use the correct solvents to stop the action. Timing is crucial—different chemicals react to different pigments and substances at widely varying rates, so that the conservator must be an expert chemist as well as a highly skilled artist. If the acting chemical is allowed to remain on the paint surface too long, it could eat it away and cause irreversible destruction. By the time the stopper is applied, it may be too late to save the original pigment. Different colors of the palette also react differently to each solvent. Some are fugitive and come off with the application of even the weakest chemicals. Others are impervious to almost anything. It takes a master of conservation to anticipate accurately the infinite combinations of reactions of chemicals to chemicals and chemicals to pigments. That is no easy task, and only a handful of people in all the United States are fully capable of the art of restoration. Knowing when a painting is fully cleaned and not overcleaned can be learned only by observing an experienced conservator many, many times. It is only through this concentrated observation that one can begin to "see" when the dirt is gone and the paint is in danger of coming off.

Unfortunately, most restorers either don't care to work diligently to perfect their skills or cannot see properly and just don't give a damn! The sin is that so many beautifully executed works of art suffer the intolerable injustice of an outsider's interpretation, and there's very little that can be done to prevent bad restoration, because there are so few people who really know what a well-restored painting should look like.

There are also too many shortcuts that can create the illusion of little or no restoration when something is in fact highly restored.

Overpaint is a common phenomenon in the art world. It is simply the painting *over* of a damaged area with new pigments. It is *never* legitimate to overpaint, and it is an unreasonable abuse to repaint the entire area of a work instead of just repairing the isolated sections of damage. It's much easier to repaint a large expanse of canvas where no meticulous attention to detail is required, rather than to tailor the necessary restoration, called inpainting, to the damaged area. It is all too common for a painting to have a large (50 percent or more) area of overpaint which covers a one-inch tear or a minuscule hole. This is not restoration! It is a cover-up used by incompetent restorers. It is like using an excess of makeup to disguise an eruption of acne rather than seeking the source of the inflammation and correcting it.

Proper restoration is very expensive and time consuming, but it is worth every dollar and minute. The cost of canvases, stretchers, and solvents (often bound to the oil price increases of OPEC because many are petroleum distillates) continue their regular upward journey, and if a restorer has several technicians in his workshop, his labor costs are also sure to rise steadily. But the real price you should expect to pay is for your conservator's expertise. His time and efforts deserve proper remuneration, for he is a most highly skilled professional. If your painting is in for major surgery, the tab will be high; if there is sufficient value in the painting, then it will justify the cost.

If a damaged painting will be worth only $1,500 in good condition, it doesn't pay to save it when the restoration costs will be $1,000, especially if you've paid a couple of hundred dollars for it.

Today's costs of framing and restoration are squeezing some markets out of existence. For example, we've stopped buying paintings for a few hundred dollars that require $500 in restoration and another $300 for framing, when they can be sold for only $1,500. To profit by $300 or $400 is to lose money in today's economy. It may take a long time to sell a modestly priced painting, and the profit will be eroded by the time the capital is reclaimed.

Obviously, size is a factor when computing restoration costs. Usually the larger the item the greater the cost. There are smaller paintings, however, that will require more detailed work than a larger painting, and so the price for restoration on the smaller painting will exceed the price for the simpler work required for the larger painting. The price will include the cost of canvases and stretchers plus the restorer's fee.

The variable dollar is that of restorer's fee. You can expect to pay on one of two bases: a fee for the restorer's time, or a percentage of the value of the painting. As incredible as it sounds, those who use the latter method will do the same amount of work on two paintings but charge much more for the higher priced painting. You'll pay a considerable premium simply because you have a valuable work of art. Avoid the restorer who uses this method. You can have no confidence in either the need for the work or the quality of the performance.

The pricing strategies of most restorers vary so that there is no standard upon which you can rely. Some even charge by the inch—an extraordinary concept. Since you cannot always be assured of getting what you pay for, seek expert guidance for a reference to a conservator and verification of his estimate.

Inpainting is the delicate process of literally painting in the damaged areas of the canvas and should only be done with nonyellowing pigments. This is an exceptionally difficult and precise operation which the restorer should practice religiously for years before even attempting to learn the other facets of restoration. When a straight line must be filled in properly, it must first be brought up to the same level as the rest of the painting, for the paint loss in that line will have left a cavity which, if directly inpainted, would be several layers below the rest of the surface.

The preliminary step is to spray the cavity with a very thin layer of varnish (no more than one thousandth of an inch) to protect the character of the painting. The restorer should not flood the painting and hide the damages, as is commonly done by unqualified technicians. After the varnish it is necessary to fill in the depression with a substance called gesso, which is close in composition to plaster. Other substances such as wax and clay may be used but they do not work as well as gesso. After the damages are filled in—they should *not* be overfilled—the gesso is evened off very carefully with the aid of a cork. Another very thin layer of varnish is then applied to the entire surface. It is only now that the inpainting should be

started. Unfortunately, it is the practice of some restorers to paint directly on the surface of the paint. This can be disastrous for future restorations because the new paint becomes a part of the original paint, making it practically impossible to remove.

Contrary to popular misconception, when inpainting is done, it is not a matter of straight brush stroking. The master's method involves hours and hours of tedious application of dots; hundreds of different colored microscopic dots to restore the original color, character, and feeling that the artist intended. Very few restorers have the specialized knowledge of this procedure and the discipline to carry it out thoroughly. The common tendency is to paint in and far around the damaged area as well— a shlock job done with the excuse (they'll call it reason) that the artist intended you to view the painting from a distance. "See how all the color blends together; you can't even detect any restoration!" they'll argue proudly. Of course you won't see it—the airbrush did a superb job of masking it with an ever-so-thin layer of transparent overpaint. If there was a medium used with the paint, you might very well discover a hidden surprise a few years later—a color change that causes the restoration to shed its invisibility.

A major step which precedes the inpainting program is relining. When a canvas is wrinkled, torn, abraded, or too loose and floppy, it should be relined. This is done by placing a new canvas behind the old one and bonding the two with wax or glue. The idea is to reinforce the original canvas and give it new strength.

There are several new types of bonds for relinings, but the best is still wax. If the wax is a blend of the proper ingredients it will be the most durable and the most permanent. Glue relinings are common even though they offer less stability. Changes in the weather can make the canvas move, and because there is always some water in the glue, the composition is affected by humidity fluctuations. As that water evaporates over the years, the canvas will very likely shrink. In the event that the relining has to be removed, the glue may cause a serious problem; it is a difficult bond to loosen without inflicting damage to the painting.

Fiberglass has also been used in the relining of paintings, and though the manufacturers will boast of its tensile strength, etc., it does not work well in relining paintings. It is simply too difficult to manage and control. It can wrinkle, and it doesn't always hold up well. When heat is applied to one section for bonding, it sometimes affects a completely different area of the painting. Frequently the fiberglass is simply not strong enough for the weight of the painting. The purpose of using fiberglass is to avoid losing an inscription or signature on the reverse of the canvas. Fiberglass is nearly transparent, so the writing would remain visible. It is better, though, to take good 8" x 10" black and white glossy photographs of the inscription and do a proper wax relining.

There are instances when one method may not work as well as another. Though glue relinings are seldom preferred, they would be desirable whenever a painting had been previously glue relined and again needed to be

relined. In such an instance glue should be used because wax could weaken the old glue relining.

With few exceptions wax relinings are the safest and most efficient. Experiments are being conducted with newer materials such as plastics and other synthetics, but it is really too soon to determine their effectiveness. In time we will learn about their durability and permanence.

Quality is significant when dealing with restorations. Solvents, stretchers, and canvases all vary as much as the restorers themselves. The best restorers use only the best of materials. A fine-grade canvas costs about thirty-four dollars a yard today, but there are inferior grades that can be had for much less, with the risk of the canvas falling apart in a short time. Stretcher quality also varies considerably, depending upon the type, age, and grade of wood.

There is also an interlining or interfacing that is becoming more widely used in relining paintings. The interlining is basically a flexible material placed between the old and the new canvases for added strength in the relining. The material—for example, Pellon—is pressed with wax onto the reverse of the old canvas and then the new canvas is affixed to the back of the Pellon. The Pellon interlining is supposed to achieve a greater degree of flatness but it sometimes creates a pattern of its own, which becomes visible in the painting.

The basic concept of an interlining is sound. Presently, many different substances are being experimented with to discover one that will serve its purpose without adverse effects.

There are certain tools that can be used to detect restoration, and some are very effective. There is the danger, however, of misinterpreting the data that is gathered. Examination by ultraviolet light is probably the most common method, and probably the most misunderstood as well. Restoration often appears dark purple or black under the ultraviolet lamp because more recently made pigments fluoresce. However, some varnishes, which grow more dense with the passage of time, are impenetrable by ultraviolet or "black light" as it's known in the trade, so the varnished area would appear dark purple or black. Also it is important to note that some of the original pigments fluoresce naturally, and may be construed falsely to be restoration by someone who doesn't know the difference.

Infrared can also be a useful tool for the detection of restoration, but again the data must be interpreted correctly. Infrared penetrates varnishes slightly deeper than ultraviolet. Overpaint can be seen somewhat more readily and the validity of a signature may easily be disputed when another one shows underneath it. In this way infrared can prove to be valuable.

Another well-known method of uncovering deceptions uses an X-ray examination. This is done primarily in the conservation chambers of museums. X-rays can detect cracks and help to determine whether they run through the paint. For instance, if a painting is not cracked on the top surface, but an X-ray shows that it is cracked underneath, it would be reasonable to believe that the top was changed or overpainted at a later date.

X-ray is also helpful in determining whether a painting has another painting beneath it. It can even be used to learn whether worm tracks are real or fake.

One ingredient that defies X-ray examination is a pigment that contains lead, such as certain white pigments. Even though an X-ray will not penetrate them, this too serves as a clue to identification of an artist's work. If this type of pigment is found repeatedly in paintings of the same style, the combination can perform the function of a characteristic fingerprint.

As revelatory as any of these systems of detection may be, they are still bound by the skill of the interpreter, for the diagnosis itself is as critical as the information.

One word of warning with regard to restoration: Never try it yourself! Always leave it to the professionals. Don't attempt anything more sophisticated than very lightly dusting your work with an extremely soft feather duster. Don't use water on it. You might consider water to be harmless, but it can be extremely damaging! You are better off by far simply leaving the work alone. It will be many, many years before the services of a restorer are needed, and then it should only be cared for by a qualified professional.

Chapter 9
Fakes and Experts

The most frightening nightmare of art collectors, dealers, and auctioneers is the fake. This is a relatively worthless object created by a ruthless, insensitive, utterly selfish individual, and has generally been sold at an embarrassingly high price. Dealers (most, anyhow) want no association with fakes, innocent or otherwise, because once there is such an association, it creates an irrevocable sense of mistrust and suspicion in the mind of the consumer. If a dealer earns a reputation for handling fakes or other fraudulent works of art, he will soon be avoided or approached with the greatest misgivings, and that is a reputation that no dealer can long sustain.

Auctioneers, for the most part, will strenuously avoid anything to do with a fake, though there are some who either don't know the difference or plainly don't care whether they handle fraudulent works. If an auction house makes a habit of passing fakes, knowingly or otherwise, it must sooner or later suffer a measurable loss of business.

The collector, upon discovering a fake among his acquisitions, will be shaken. He may lose confidence in

the dealer from whom he bought the work—either the dealer failed to recognize the fake or he intentionally took advantage of the collector's inexperience and sold a work he knew was fraudulent. Furthermore, you, the collector, lose confidence in yourself, in your ability to recognize a fake when you are presented with one. If you are wise, you will learn from this incident that you need advice to protect yourself from another disaster. If you've been lucky and have never been stuck with a fake, you can still benefit from the following insurance policy. (I have said it before, but the advice is even more important in this context.) *Deal only with the most reputable of galleries, dealers, and auction houses.* Make certain that you can return for full cash refund, or for an equivalent work, any work of art, painting, drawing, watercolor, or sculpture which is later discovered to be a fake. If you don't have such an arrangement prior to consummating your purchase and the purchase turns out to be a fake, you may never regain your money. I suggest a consultation with your attorney regarding the applicable laws in your state.

As I mentioned, most dealers, galleries, and auction houses won't touch fake or even doubtful work, but there are some who will do anything for money, and they cause trouble for everyone else throughout the industry. The odds against being victimized are very much in your favor as long as you continue to deal solely with the reputable houses. Even if a fake is so successful that the dealer is hoaxed, you are protected. If you have made purchase of a painting sold as a Mary Cassatt, for example, and it is later determined by an expert that it is a copy rather than

an original, the reputable gallery will take it back, return your money, or allow you a credit.

Let's clear a popular misconception about reproductions, replicas, and copies. *Reproductions* are not originals but likenesses mass-produced by mechanical means—lithography, offset, etc. *Copies* are painted reproductions of great works—attempts by other hands to duplicate the same subject. Many copies done in the nineteenth century were emulations of works of earlier centuries, and some are close enough to be deceiving, even if they were not intended to deceive. Occasionally, where fraud was the motive, nineteenth-century works have been dirtied up with old varnishes, which had been salvaged for just such a purpose, and the works were then represented as seventeenth-century paintings. This kind of fraud is hardly novel—it goes back to ancient times. *Replicas*, on the other hand, are not copies of anything. They are separate and individual renditions of the same thing. Gilbert Stuart, an American portrait painter of the eighteenth century, made many replicas of his portraits of George Washington (roughly 125), and though the variations among them are slight, they are all individual works of art, not copies, and their value is not decreased by the fact that the theme is the same with or without variations.

At least once a week we are offered as genuine oil paintings reproductions which have been painted over, or prints which have been varnished carefully to make them appear like drawings. Certain prints can be made to resemble watercolors to the extent that the colors will run if tested with water. Twentieth-century oil paintings

can be copied (and have been in many instances) and passed as authentic to museums, dealers, and collectors, with provenances that are manufactured or approximated from others which are genuine.

So, how does one protect oneself? In addition to dealing with reputable firms, consult the proper experts. I say *proper* experts, because there are, on the one hand, those who have rightly earned the title through years of scholarly research and study, and on the other, those who fancy themselves to be quite expert merely by self-proclamation. In jest, the standard definition of an expert is the guy from out of town, and the "expert" who comes from the farthest distance is sometimes considered the most knowledgeable.

Reaching the experts isn't always easy or convenient. There are scholars whose expertise is in the work of a specific artist, and there are those whose expertise lies in the work of an entire school of painting. Often these people are out of the mainstream of everyday business, and so completely immersed in their scholarly research they remain virtually unknown even to the professionals. There is always someone, however, who does know who they are and where they are to be found. The best way to locate them is through museum department heads, dealers, and by watching auction catalogs, where you can find the names of persons who are compiling or have recently compiled a catalogue raisonné for a specific artist.

Sometimes there is no expert on a particular subject because no research has been completed or even started. If this is true of an artist in whom you are interested, then

you do have a problem. If no one is studying your subject—guess what? That's right—start researching. You'll be amazed at the amount of information you can obtain in libraries, museums, and galleries. Frequently, vast amounts of previously unpublicized information exist. Adding the most recent information and consolidating the whole is not too arduous a task. When you complete the task, there's a bonus waiting for you. You not only obtain the information you need for yourself, you are now considered the expert on your subject. An excellent means of obtaining recognition of your expertise is publishing an article describing your findings and conclusions.

If there is no expert to be found for the subject that interests you, the next best thing (and sometimes the best thing) is to consult with a group of well-respected, knowledgeable dealers, well acquainted with the works in question, as a course of their regular dealings. If they agree about the authenticity of your item, you can feel reassured. If they agree that the work is dubious, you will be able to make an intelligent decision about it.

Experts, however, are not always the last word; the general rule is as follows: if an expert whose opinion is highly regarded says that your work is incorrect (that is, contrary to the attribution), then it is incorrect for the time being, whether or not it is finally adjudged incorrect. Of course, experts are only human and can make errors in judgment—sometimes for lack of sufficient information or by accepting misinformation. They may change their minds if presented with fairly conclusive evidence to support an opinion to the contrary. Fence jumping does

not happen daily, but it does happen, and it is perfectly legitimate.

There are items open to dispute. A past scholar, for example, may have stated and cataloged a particular painting as one painted by Rembrandt, whereas current experts question the attribution and list it as "school of" or "follower of" instead. This is generally known as the "latest book theory," in which the expert who has written the most recent scholarly work is considered the foremost expert. What to do if your Renoir or Rembrandt or whatever has been dethroned? If there is no matter of urgency (an imminent donation, perhaps), sit tight and ride out the storm. There could well be another change of heart upon the discovery of new findings, or another text might be in preparation by a new but equally respected scholar who might reclassify your work as authentic.

Strange things happen in time, and it pays to wait, even if nothing changes. After all, if you love the painting as an object of beauty, it doesn't really matter who painted it—unless of course, you paid a price for one thing and got another.

There can be still another problem when you are seeking an expert's opinion. There may be two or three experts in the field, and you must make a choice. You can obtain a dealer's opinion as to the best selection, for generally there is one outstanding expert in each field, and that would be the one to whom the dealer would turn. If you don't get the satisfaction you are seeking try the second and possibly even the third. Often each will reinforce the advice or opinion of another. It is not unusual for them to

consult with each other and formulate a common statement. It is also not unusual for two or more experts to have diametrically opposed opinions, with none of them willing to step down. There isn't much you can do unless your future dealings for the work are with people who respect the scholar with the positive opinion. Being in the middle of expert crossfire can be an agonizing experience, because it can sometimes take years to reach the truth, and sometimes, even worse, there is no resolution.

When you correspond with an expert or scholar, in addition to the initial introductory letter concerning the work in question, submit either an 8" x 10" or 4" x 5" color transparency as well as one or two 8" x 10" black-and-white glossy photographs. If there is any provenance or family history, it would facilitate matters to include it along with a description of signature, inscription, size, medium, and condition. You may in return receive an opinion, or a request for shipment of the work itself. In the latter case you will be expected to prepay all expenses of crating, shipping, and insuring, as well as any customs and forwarding fees. The final fee is that of the expert's authentication or opinion. The fees may vary from none for certain scholars, who are eager to help for the pleasure of it, to upward of $1,000 for others. If an expert comes to you to examine your work of art, you can anticipate that he will charge, and justifiably so, for his travel expenses as well as his opinion, which you should get in writing. The fee schedule may vary, usually higher if your work is genuine, and lower if it is a fake or other than what it was purported to be.

This is not a universal practice, but it is used by some experts to set their fees.

Recently I was offered a small group of paintings represented as works of Raphael and Da Vinci. Two were paintings by Raphael, and one oil and two drawings were by Da Vinci. I was presented with photographs and photocopies of letters of authentication from a restorer in Italy whom I had never heard of before and couldn't trace anywhere. I was informed by the prospective seller that this "famous restorer" was *the* renowned expert on the work of both Raphael and Da Vinci. I realized at once that the deal was a fraud, for I knew who the acknowledged scholars were. I invited the gentleman to leave and then informed my colleagues of this scam to avoid any further deceptions. There is a loyal network among art dealers, which serves in the protection against and prevention of frauds. The letter from the alleged "expert" did turn out to be a fake. The paintings and drawings, if in fact they really existed at all, were either stolen or were being offered with the provision that they be paid for first, and then either they would never be delivered or some poor substitutes would arrive.

This incident provides further proof for the dictum: Don't get involved in deals that sound impossible—they generally are just that. Avoid the long shot. Acquiring works of art within the proper channels, you will avoid anything to do with fakes and fraudulent schemes.

Chapter 10
Insurance, Appraisals, Security, and Shipping

One of the securest protections from risk to collectors of fine art is insurance. People insure their homes, their jewels, their cars, their furs, their boats, their airplanes, and their lives, so why not their works of art? Art can be stolen, damaged, or ruined. It is logical to protect the works by taking out insurance for them, and the simplest way of doing so is through your own insurance consultant. The application is similar to that for any standard type of insurance. One strong recommendation though—do not allow your works of art to be covered exclusively under your homeowner's policy. The coverage is inadequate because if, for example, your precious sculpture by Rodin topples to the ground and dents or smashes, you're out of luck. Most homeowners' policies allow for fire and theft, but do not cover natural disasters like floods or accidental acts committed by visitors. If, however, your works of art are included on a *scheduled form of all risk*, they would then be covered in the event of theft, fire, or breakage. It is imperative to schedule any of your fine art that you know is valuable. To help keep the insurance cost moderate,

allow a decent deductible (minimum of $1,000) and be selective in the items you insure. It's impractical to insure everything, unless the need to do so is absolutely warranted. If you have amassed a substantial collection, all of important quality, then of course it will be necessary to insure it all at the current values, and if the value of each is very high, it will pay to maintain a high deductible. If one decent-size painting is worth $15,000, and it falls off the wall and suffers a broad tear, it'll cost at least $1,000 to have it restored properly, so that it really pays to finance the work yourself and save the insurance coverage for a major loss such as theft or fire.

If you have the money to collect expensive works of art, you don't need insurance companies to pay for your minor mishaps. Save the insurance for a real need, and if you never need it, so much the better. Think of the premiums as an investment in sound sleep and peace of mind. And, speaking of premiums, you can well expect that your rates for insurance will be based on several variables, but as a rule of thumb, fine-arts insurance is relatively inexpensive. For paintings, drawings, watercolors, and prints, a very approximate rate is .25 percent of the value. (For example, a $100,000 painting could be insured for a $250 premium.) Sculptures and ceramics insurance costs somewhat (sometimes rather significantly) more because of the breakage factor. The rate is figured by combining an assortment of factors: geographic location (rates for New York are much higher than those in a small midwestern city); type of home construction (rates for frame houses surpass those of an old stone home, and an apartment

house or complex will cause higher rates than a single dwelling because there are other people's liabilities to be considered); proximity to the fire department (the more remote, the greater the premium); type of alarm system if one exists at all (fire, smoke, heat, burglar) and whether it sounds a loud bell—the more efficient and complex the system the lower the rate. Overall the rates are minimal for the protection you receive in return.

In the event of a loss, whether the result of a theft or vandalism, the insurance company will try to find you a comparable example for replacement if it is at all possible. This is generally very difficult when dealing with works of art, since in most cases, each is unique. If they happen to find something of comparable quality, nature, and value, then you are obliged to accept it as a replacement. If they cannot present you with a suitable substitute, they will reimburse your loss with money. There is no standard percentage for reimbursement. The insurance concerns will almost always dispute your appraisals and go to other dealers to verify your claim. Let's say you've paid a record high price of $160,000 for an impressionist landscape by Theodore Robinson, depicting two women seated under their parasols on a hillside. The dealer from whom you've made the purchase gives you an appraisal for $160,000 for insurance purposes. Six months later your home is burglarized and your painting together with jewels and other valuables is stolen. The police, FBI, newspapers, insurance company, and a host of art dealers and museums are notified immediately. Months go by (a sufficient amount of time must be allowed the insurance company

to try to recover the stolen goods or make a replacement), and your painting cannot be found, nor can a comparable example be found. So, you expect that your original bill of sale and appraisal, both in the amount of $160,000, are a fair approximation of the value. The insurance company disagrees and insists that since you paid a record price, you overpaid. No comparable example ever brought such an exceptional price. The insurance company will try to confirm their theory by approaching some other well-respected dealers, asking their opinions about your appraisal and the current value of your painting. If a couple of them deem $160,000 excessive and declare $145,000 closer to a fair market value, you'll be paid the lower figure by the insurance company. However, if you purchased the painting from a very respectable gallery, you won't have overpaid even if you paid dearly, and chances are the market would have appreciated to some degree in six months so that the insurance company would find that other dealers would unanimously confirm your appraisal or even state that it was slightly lower than the fair market value. In that case you would be reimbursed the appraisal value, but no more.

This situation emphasizes the real danger of being underinsured. The way to prevent this is to keep a close watch on the art markets in which you have made investments and to conduct an annual or even semiannual review, depending on the activity of your type of art. Obtain current appraisals as they are necessary and adjust your insurance coverage accordingly. This will protect you from an even greater loss that would occur if you were

not covered for increases in the value of your art. It will also protect you in a situation where your dealer might have gone out of business or might have died between the time you purchased your work of art, and the time you incurred the loss.

It is always good policy to keep a slide and photographic record, copy of the original bill, and a copy of a current appraisal off the premises in a vault or similar safe place. If your insurance company is on its toes, they will request that you furnish them with an updated appraisal from a reputable dealer (though they won't define "reputable"), on an annual basis. They will definitely ask that you submit an appraisal to them at the time of or shortly after you make your purchase before they will provide insurance.

There are lots of dealers who are qualified to make appraisals, and there are also people who do only appraisals. You will also find people who don't know enough to do a proper appraisal, but who will do one anyway because they can make money. Here again, you must be careful when you select someone to do your appraisal work. A museum recommendation is highly desirable, and there are reputable appraisal associations to whom you can go or call for the names of members in good standing with proper qualifications who will be able to help you.

A few candidates for assistance or referral are The Appraisers Association of America, 541 Lexington Avenue, New York, NY 10022 (212-867-9775); The American Society of Appraisers, 11800 Sunrise Valley Drive, Suite 400, Reston, VA 22070 (703-620-3838), and

The Art Dealers Association, 575 Madison Avenue, New York, NY 10022 (212-940-8650).

There are other regional associations, but these are the three with which I am most familiar by reputation and experience.

Appraisals generally follow a fairly standard format in our industry. They should include, either on an association form or at least on a dealer's letterhead, the name and address of the gallery, the name and address of the person or estate for whom the appraisal is being done, the date of the appraisal, the title of the article, the artist and his dates or school of painting with the century, notation of date, and signature if available, size, medium, condition, and a description of the subject matter, with the value at the time of the appraisal. There should also be a notation as to whether or not the work is framed, and the appraisal should be signed and dated by the appraiser himself. If photocopies are made, each copy should be signed immediately; the original should be signed and dated after it has been copied. Normally, the gallery keeps one copy and the collector gets two copies, one for himself and the other for his insurance company.

As for the fee, basically, there are two different methods of charging: one is a percentage of the value, and the other a flat fee. In my opinion, when an appraiser exercises his skill and gives his service, he is entitled to a proper fee; this pays for his time, his efforts, and his accumulated knowledge. He is not entitled to credit for the artist's skills, which is in essence what he takes when he charges you a percentage of the item's value. Why should

you be penalized if you have something of great value, or for that matter, be charged very little if your work of art turns out to have little value? I think that is unjust and inequitable; it takes the same time, expertise, and effort to determine the value if the work is highly valuable or worthless. In fact, you would hope that the appraiser would be honest enough to tell you point-blank that an item isn't worth appraising if that were true. All too often, though, insignificant items, especially under the percent-of-value method, will be included to build up the overall total so that the fee can be built up as well. It would seem more justified to increase the fee commensurate with the amount of research involved, and that is precisely the way it is done when a flat fee is charged. The fee will vary significantly throughout the industry so that the easiest way to learn what the charges will be is to make some calls. The percentage figure also varies considerably but it generally ranges from 1 percent to 1.5 percent of appraised value.

Insurance companies will feel somewhat more at ease if they know you have some system for security. Alarm systems are a great help, for at the very least they are a good deterrent. They range from a simple bell-sounding type to the complex central-station motion-detection alarm, which notifies the police, the alarm company, and may even turn on your lights, emit an ear-piercing sound, and photographically record the intruder. The more sophisticated, the better, and the same goes for fire protection. If your system detects heat, smoke, and fire and is central station (alerts the fire department), your chances for

walking away with your art are much better than if you have only smoke detectors.

A good photographic record can be of immeasurable benefit in cases of theft; it facilitates distributing full descriptions to the authorities and makes it possible to obtain widespread publicity in newspapers and other media to alert anyone who might be solicited for the purchase of your art. Photography today is made so simple that there is no excuse but carelessness for not making Polaroids, 35mm slides, or black-and-white photographs of your works of art.

Under normal circumstances, it is the collector's responsibility to finance the crating and shipping of paintings, drawings, watercolors, sculpture, furniture, and other objects of art when a purchase is made. There are a few exceptions—favored clients or purchasers of very high-priced items—when packing and transportation are charged to buyers, and everyone is happy. It is generally our policy to absorb the costs of building and sending out the crate for a work of art if someone is spending $15,000 or more with our gallery. If, however, a client wants a painting shipped out on approval after seeing it in an advertisement, we will pay the shipping going out and the client pays the return cost if he decides not to keep it. The cost of the crating can be split, or absorbed by either the seller or the purchaser. There is a fair amount of flexibility in this, and in certain cases the client will be required to pay all costs if the transaction is on an approval basis rather than a firm sale.

We will not ship any art to anyone we don't know, unless the customer provides us with a couple of solid

references, which we can and will investigate. We may also on occasion request advance payment in full, which must clear the bank before we'll ship the work. If a sale does not transpire, we then refund the purchase payment (possibly minus crating and/or shipping). This may seem arbitrary, but it really is the only way in which a gallery can protect its interests, and it's industry-wide practice.

We feel that the best method of packing is to use sturdy thick wooden crates. The crates can be either disposable or reusable, the difference being that nails are used to close the disposable box, whereas the reusable is sealed with screws. We advocate the reusable box, and though it is somewhat more costly, it is infinitely safer. There are no nails to hammer so there are fewer jarring vibrations to disturb the contents. Also, when the crate arrives at its destination, it is much easier for the client to open; the risk of an inadvertent slip of the chisel or hammer is absent when the case can be easily opened with a screwdriver. If the client fails to buy the painting, the odds are much better that it will return in the same condition that it was in when it left.

No expense should be spared to wrap the contents of the crate. The idea is to make perfectly sure that the shipment is safe and will arrive unchanged. All paper used should be nonacid, so that if there is any contact with the object, the paper will not affect it. The work of art should be wrapped so well that it won't move at all within the crate. It should be cushioned on all sides, and have several inches of clearance (six inches is optimal) in any direction. This is for protection in the event that something

is dropped onto, or banged into the crate, penetrating the wood case. Such penetration can spell disaster for the contents unless they are securely insulated and strategically located.

It is definitely advisable to insure works while they are in transit. The rates will depend on the weight, the distance they travel, the nature of the cargo, the value, and mode of transportation. The rates for trucks differ from those of planes, and those of overseas freighters differ from both. It is possible to insure art no matter how it travels, but the maximum limit on truck shipments is $500,000 per truckload. Most airlines insist on the shipper fulfilling certain conditions, which they (airlines) must approve, before they will accept shipments valued at more than $500,000. If you can procure insurance by the carrier, the average premium will run $2 to $3 per thousand dollars of value, but frequently even as high as $6 per thousand.

For safety and speedy delivery the best carriers are Federal Express, Emery, and Purolator Courier. The United States mail sometimes offers a good package service, though it's not very quick. In addition, you can only insure for $25,000—any extra coverage must be carried by your own private insurance company. There is an additional premium for overnight service, and it is only available in certain designated cities, but the list of cities is growing daily and has already reached a sizable number.

To find someone to do your crating and packing, consult the major museums, major auction houses, or major galleries in your locality and ask which firms they employ,

because, although there are a great many warehouses who brag of their professional skills, few have the right to handle fine works of art.

Chapter 11
Tax Benefits

Collectors of fine art should be aware of the taxes that apply to outright sales, trades, and charitable contributions of works of art. Tax liabilities are related to the frequency of such transactions. If you show a steady series of purchases and sales, you will in all probability be considered a "dealer" by the Internal Revenue Service. The more frequent the transactions, the greater the likelihood of falling into the dealer category. IRS has established no absolute criteria, but if you can limit yourself to three or four deals per calendar year, you should be able to avoid the classification and retain the investor status.

If, however, one of your deals involves an estate containing a hundred or more pieces of art, the size of the deal may jeopardize your investor standing. IRS could conclude that only a dealer could handle a transaction of this size, especially if it entails advertising, promotion, record keeping, and a period of time to dispose of all the items. Obviously, all such activity is that of a dealer. Though their reasoning may not be accurate (because you

don't have to be a dealer to administer an investment over a period of time), IRS can be both persuasive and persistent. If you should purchase a sizable collection—let's say 150 works of art, paintings, sculpture, and prints—the best way to protect your investor standing is to sell the items gradually. If you exhibit a trickle of activity, rather than a total effort, you are less likely to be classified as a dealer.

The important advantage you lose when your status changes from investor to dealer is the capital-gains tax. If you acquire a work of art for investment, you are required by law to hold it for a minimum of one year before selling it in order to qualify for a capital-gains tax. The benefit is obvious in that the ceiling for ordinary income tax at present is 70 percent, whereas the maximum capital-gains tax is 28 percent. In addition, the first 60 percent of the capital gain is excludable so that only 40 percent of the total gain is subject to tax—quite a break. As an illustration, let's take the case of Dr. X who purchases a painting for $100,000 on July 1, 1979, and holds it until December 1980 (almost a year and a half) when he contemplates selling it to finance a new acquisition. Time has been good to him—his painting is now worth $140,000, a substantial appreciation (40 percent) in such a short time. Should he hold it for even greater growth or sell now and buy that other painting that's nagging at him? Well, he decides that the new one will grow at least as well as the first, maybe better. So, he decides to sell the first for $140,000. He can now take advantage of the capital-gains tax. His gain is $40,000, but as I mentioned

earlier, only 40 percent of that is taxable ($16,000) and at that only at the individual's own tax rate, which is 70 percent maximum. If the doctor were in a 50 percent bracket, he would be liable for $8,000 in gains taxes on this transaction; a far cry from the $20,000 tax he'd owe through the ordinary income tax method.

The government provides this substantial tax savings to serious investors in art with this qualification: if the capital gain is deemed overly large by the government, so that the total tax is relatively minor, you may have to pay what is termed an alternative minimum tax. This is exceptionally rare, though, and would probably occur only if the investor's tax bracket were *very* low and the capital gain was excessive—an unlikely combination. Most people who are going to make any appreciable investments in art have some discretionary cash to spend and have sufficient income to place them in a fairly high tax bracket.

The contribution of works of art that have appreciated can also save taxes for the investor. This may seem like a simple procedure, but it is actually very complex. There is a variety of ways to make an art contribution, and each has specific regulations. The allowable deductions for contributions of appreciated art for capital gain purposes depend upon the type of organization to which it is donated, the way it will be used by the organization—whether or not it will be used in conformity to the organization's charitable exemption—and upon the possible use of a special election relating to the donor's limitations on contribution. That's almost as complicated as

it sounds, but after some clarifications the picture will brighten.

As a general rule, works of art donated to charities and privately operated foundations, including museums, are fully deductible at the fair market value on the date of the contribution. This is, of course, true so long as the organization's use of the work falls within the guidelines of its exemption status.

For example, a collector donated a Rembrandt painting to a university. The university accepted the gift and decided to hang the painting in its art reference library for educational-study purposes. That type of use by the institution was considered related to the purpose of the university so the donor was able to deduct the entire fair market value of the painting.

If, however, after the donation was made to the university, the painting was sold instead, with the intention of gathering funds for education, instead of using the painting itself, the use would have been classified as unrelated and the donor's deduction would have been the fair market value minus 40 percent of the potential long-term capital gain based on the value at the time of the donation. This reduction of 40 percent is applicable in cases where the charity's use of the work is contrary to the organization's exempt purpose, or in cases of donations to organizations or foundations to which a 20 percent limitation would apply (very special circumstances). There is also an extremely rare circumstance where a donor will elect to elevate from 30 percent to 50 percent (of adjusted gross income) his limitation on

contributions, and take the 40 percent reduction in the potential long-term capital gain as if the painting were sold. In some peculiar tax situations, this option might be of benefit to a donor.

There are two fairly standard limitations. The first arises when a capital-gain property, such as a painting, drawing, watercolor, sculpture, or ceramic object, is donated to an organization such as a museum at full market value. The donor's deduction is limited to 30 percent of his adjusted gross income. If the donor had a year's adjusted gross income of $250,000, the maximum charitable contribution in that year would be $75,000. Anything in excess of the 30 percent could be carried over for five years.

The second limitation applies if other cash contributions are made during the year to other charities or private foundations. The limit for the total contributions jumps from 30 percent to 50 percent of the donor's adjusted gross income. If a cash contribution was made by the donor who had the $250,000 adjusted gross income, and he was going to donate a work of art to a museum as well, the limit of his total deduction would then be $125,000 rather than $75,000 for the painting alone.

When making charitable contributions of art to museums or other nonprofit organizations, it is most important to substantiate the donation. This is done by retaining a description of the art, the date of the transfer, and the method employed in the determination of value. Any gifts of capital-gain property with a value in excess of

$200 should also be accompanied by a certified appraisal. The basic elements of the format of an appraisal for tax or giveaway purposes are included in the revenue procedures *(66–49)* in the final pages of this chapter, as well as a review of the valuation appraisals and the Internal Revenue's criteria which establish value.

Your records as a taxpayer should include, among other things when donating works of art, any conditions or limitations attached to the gift, the method by which the work was transferred, the cost of the art and finally the way you computed the contribution deduction if the deduction reflects a reduction of capital-gain property.

As a matter of interest, appraisal fees that are incurred in the determination of the fair market value of art to be donated to charities or nonprofit organizations are legitimate tax deductible expenses on your federal income tax return. Also, the cost of any investment publications or books relating to investments are tax deductible so that the price you've paid for this book is tax deductible, because it very definitely contains a significant amount of investment-related material.

Though you may feel very much more enlightened about the tax aspects involved in the collecting of fine art after having read this chapter, I urge you as strongly as I can to consult with your own tax accountants and tax attorneys when you are considering the donation of art to charitable organizations.

I have merely offered a synopsis of the most basic elements involved in the donation of fine art. Almost without

exception each individual tax situation is unique and should be dealt with in an appropriate manner, requiring the services of a professional.

REVENUE PROCEDURES 66–49
INTERNAL REVENUE SERVICE
Rev. Proc. 66–49

A procedure to be used as a guideline by all persons making appraisals of donated property for Federal income tax purposes.

SECTION 1. PURPOSE

The purpose of this procedure is to provide information and guidelines for taxpayers, individual appraisers, and valuation groups relative to appraisals of contributed property for Federal income tax purposes. The procedures outlined are applicable to all types of noncash property for which an appraisal is required such as real property, tangible or intangible personal property, and securities. These procedures are also appropriate for unique properties, such as art objects, literary manuscripts, antiques, etc., with respect to which the determination of value often is more difficult.

SEC. 2. LAW AND REGULATIONS

.01 Numerous sections of the Internal Revenue Code of 1954, as amended, give rise to a determination of value for Federal tax purposes; however, the significant section for purposes of this Revenue Procedure is section 170, Charitable, Etc., Contributions and Gifts.

.02 Value is defined in section 1.170-l(c) of the Income Tax Regulations as follows:

. . . The fair market value is the price at which the property would change hands between a willing buyer and a willing seller, neither being under any compulsion to buy or sell and both having reasonable knowledge of relevant facts. . . .

.03 This section further provides that: . . . If the contribution is made in property of a type which the taxpayer sells in the course of his business, the fair market value is the price which the taxpayer would have received if he had sold the contributed property in the lowest usual market in which he customarily sells, at the time and place of contribution (and in the case of a contribution of goods in quantity, in the quantity contributed). . . .

.04 As to the measure of proof in determining the fair market value, all factors bearing on value are relevant including, where pertinent, the cost, or selling price of the item, sales of comparable properties, cost of reproduction, opinion evidence and appraisals. Fair market value depends upon value in the market and not on intrinsic worth.

.05 The cost or actual selling price of an item within a reasonable time before or after the valuation date may be the best evidence of its fair market value. Before such information is taken into account, it must be ascertained that the transaction was at arm's length and that the parties were fully informed as to all relevant facts. Absent such evidence, even the sales price of the item in question will not be persuasive.

.06 Sales of similar properties are often given proba-
tive weight by the courts in establishing fair market value.
The weight to be given such evidence will be affected by
the degree of similarity to the property under appraisal
and the proximity of the date of sale to the valuation date.

.07 With respect to reproductive cost as a measure of
fair market value, it must be shown that there is a pro-
bative correlation between the cost of reproduction and
fair market value. Frequently, reproductive cost will be in
excess of the fair market value.

.08 Generally, the weight to be given to opinion evi-
dence depends on its origin and the thoroughness with
which it is supported by experience and facts. It is only
where expert opinion is supported by facts having strong
probative value, that the opinion testimony will in itself
be given appropriate weight. The underlying facts must
corroborate the opinion; otherwise such opinion will be
discounted or disregarded.

.09 The weight to be accorded any appraisal made
either at or after the valuation date will depend largely
upon the competence and knowledge of the appraiser
with respect to the property and the market for such
property.

SEC. 3. APPRAISAL FORMAT

.01 When it becomes necessary to secure an appraisal in
order to determine the values of items for Federal income
tax purposes, such appraisals should be obtained from qual-
ified and reputable sources, and the appraisal report should
accompany the return when it is filed. The more complete

the information filed with a tax return the more unlikely it will be that the Internal Revenue Service will find it necessary to question items on it. Thus, when reporting a deduction for charitable contributions on an income tax return, it will facilitate the review and the acceptance of the returned values if any appraisals which have been secured are furnished. The above-mentioned regulations prescribe that support of values claimed should be submitted and a properly prepared appraisal by a person qualified to make such an appraisal may well constitute the necessary substantiation. In this respect, it is not intended that all value determinations be supported by formal written appraisals as outlined in detail below. This is particularly applicable to minor items or property or where the value of the property is easily ascertainable by methods other than appraisal.

.02 In general, an appraisal report should contain at least the following:

1. A summary of the appraiser's qualifications.
2. A statement of the value and the appraiser's definition of the value he has obtained.
3. The basis upon which the appraisal was made, including any restrictions, understandings, or covenants limiting the use or disposition of the property.
4. The date as of which the property was valued.
5. The signature of the appraiser and the date the appraisal was made.

.03 An example of the kind of data which should be contained in a typical appraisal is included below. This relates to the valuation of art objects, but a similar detailed

breakdown can be outlined for any type of property. Appraisals of art objects, paintings in particular, should include:

1. A complete description of the object, indicating the size, the subject matter, the medium, the name of the artist, approximate date created, the interest transferred, etc.
2. The cost, date, and manner of acquisition.
3. A history of the item including proof of authenticity such as a certificate of authentication if such exists.
4. A photograph of a size and quality fully identifying the subject matter, preferably a 10" x 12" or larger print.
5. A statement of the factors upon which the appraisal was based, such as:
 a. Sales of other works by the same artist particularly on or around the valuation date.
 b. Quoted prices in dealers' catalogs of the artist's works or of other artists of comparable stature.
 c. The economic state of the art market at or around the time of valuation, particularly with respect to the specific property.
 d. A record of any exhibitions at which the particular art object had been displayed.
 e. A statement as to the standing of the artist in his profession and in the particular school or time period.

.04 Although an appraisal report meets these requirements, the Internal Revenue Service is not relieved of the responsibility of reviewing appraisals to the extent deemed necessary.

SEC. 4. REVIEW OF VALUATION APPRAISALS

.01 While the Service is responsible for reviewing appraisals, it is not responsible for making appraisals; the burden of supporting the fair market value listed on a return is the taxpayer's. The Internal Revenue Service cannot accord recognition to any appraiser or group of appraisers from the standpoint of unquestioned acceptance of their appraisals. Furthermore, the Service cannot approve valuations or appraisals prior to the actual filing of the tax return to which the appraisal pertains and cannot issue advance rulings approving or disapproving such appraisals.

.02 In determining the acceptability of the claimed value of the donated property, the Service may either accept the value claimed based on information or appraisals submitted with the return or make its own determination as to the fair market value. In either instance, the Service may find it necessary to:

1. contact the taxpayer and ask for additional information,
2. refer the valuation problem to a Service appraiser or valuation specialist,
3. recommend that an independent appraiser be employed by the Service to appraise the asset in question. (This latter course is frequently used by the Service when objects requiring appraisers of highly specialized experience and knowledge are involved.)

Rev. Proc. 66–50

Procedures for changes in accounting period from a fiscal year to a calendar year by individuals whose income is derived solely from wages, salaries, interest, dividends, capital gains, pensions and annuities, or rents and royalties.

Chapter 12
TYPES OF ART TO INVEST IN

The following pages house a series of very concise summary descriptions of the various periods in art history that are among the most significant and highly regarded of our past. This is no attempt to compete with encyclopedias, which one would need to cover exhaustively all of the primary schools of painting, sculpture, and architecture, as well as all of the subgroups and offshoots which developed out of these and other influences. There are periods in art history which overlap and make difficult their precise dating, and it can always be argued that certain dates are incorrect because of one or two artists who were still working within the tradition of the style, but beyond the dates of the period.

I have listed numbers of artists as examples of each category I have described. For practicality I kept these lists to a minimum. Some may disagree with my choices, believing other artists to be more typical, or perhaps better known, but my goal was to include some familiar figures while suggesting some of the little or unknown heroes of the specific periods. It should also be said that it

is a sizable task to assign specific artists to each category without overlapping. Many of the names I've included under certain classifications may easily fall into other descriptions as well, because the artists often completed oeuvres of one style early in their lives, while exhibiting full-blown characteristics of another style later in their lives. This is true of both the European and the American artists, for the divisions in labeling usually result from the differing conclusions within the available scholarship.

EUROPEAN

Gothic

The painting of the Gothic Period encompasses the thirteenth to the fifteenth centuries. The emphasis in art was on human values, showing a distinct departure from the prior accent on idyllic images with stress on the theological. A new aim at secularism was formed. Narrative subjects were blended with sentiment and humanity while landscapes eventually adopted a new sense of panorama by incorporating a spatial quality that was not known before. The Sienese painters were probably the most significant of any in the Gothic Period, for their innovation and influence was widespread. All of the European countries were affected, but Florence and Siena in Italy were the prime areas of creation.

The tradition of absolute medievalism of the thirteenth century gradually transformed itself into a more decorative, flowing quality in the fourteenth century, which was to continue into the fifteenth century.

Gothic

Fra Angelico
Giotto (di Bondone)
Gentile da Fabriano
Duccio (di Buoninsega)
Benozzo Gozzoli
The Limbourg Brothers
Ambrogio Lorenzetti
Simone Martini
Lippo Memmi
Masolino di Panicale

Cenni di Pepo Cimabue
Sano di Pietro
Antonio Pisano Pisanello
Stefano di Giovanni
 Sassetta
Lorenzo di Pietro
 Vecchietta
Domenico Veneziano
Marco Zoppo

Renaissance

The Renaissance by definition means a rebirth. This is a concise description of the period that spans the fourteenth and fifteenth centuries. The emphasis in painting was placed on the importance of the individual and his world. The human body became a point of interest, and stress was placed on the physical appearance of the space which surrounded it. Man and his world were reborn; artists of the time employed new dimensions in perspective—linear, aerial, and anatomical—and furthered the sophistication of this new development in art by the application of geometric principles.

The Renaissance Period had its roots in Italy, notably in Florence, Siena, Padua, Venice, and Rome, but was later to spread throughout Europe. Art of the Renaissance was highly individualistic and continued to place strong emphasis on the secular.

Renaissance

Gentile and Giovanni Bellini

Sandro Botticelli

Brunelleschi

Vittore Carpaccio

Andrea del Castagno

Francesco Cossa

Carlo Crivelli

Donatello

Piero della Francesca

Francesco Francia

Domenico Ghirlandaio

Francesco di Giorgio

Giorgio Giorgione

Benozzo Gozzoli

Fra Filippo Lippi

Andrea Mantegna

Tommaso di Giovanni di Simone Guidi Masaccio

Antonello da Messina

Michelangelo

Pietro di Cristoforo Vannucci Perugino

Francesco Pesellino

Bernardino Pinturicchio

Antonio Pollaiuolo

Raffaello Santi Raphael

Ercole De Roberti

Cosimo Rosselli

Cosimo Tura

Domenico Veneziano

Leonardo da Vinci

Mannerism

Mannerism in its early stages (around 1520) is really the late Renaissance. In essence, it was an active revolt against classicism characterized by a movement of emotions and unrestrained depictions of the fantastic, in conjunction with an intense passion for everything intellectual. Things normal and slanted with rationality were "mannered" or transformed into a higher creation of elegance with the spirit of humanism ever present. Proportion and space were altered, movement was distorted, and the social and intellectual complexities were fused so that the ordered natural perspective of the High Renaissance became very

exaggerated. The creation of Mannerism came about in Florence, developed in Rome, and then caught on in Fontainebleau, France, after which it spread to Spain, Germany, England, and the Netherlands. The period lasted until about 1620.

Mannerism (Late Renaissance)

Niccolò dell' Abbate
Albrecht Altdorfer
Giuseppe Arcimboldo
Balthasar van der Ast
Jacopo Bassano
Domenico Beccafumi
Osias Beert
Henri met de Bles
Abraham Bloemaert
Hans Bol
Paul Bril
Angelo Bronzino
Pieter Bruegel the Elder
Jacques Callot
Antoine Caron
Pieter Claesz
Joos Van Cleve
François Clouet
Lucas Cranach

Monsu Desiderio
Dosso Dossi
Rosso Fiorentino
Frans Franken
El Greco
Juan van der Hamen
Maerten van Heemskerek
Lucas de Heere
Francesco Mazzola
 Parmigianino
Joachim Patinir
Clara Peters
Jacopo da Pontormo
Sebastian Stosskopf
Jacob Isaacsz van
 Swanenburgh
Jacopo Robusti Tintoretto
Giorgio Vasari

Baroque

The Baroque Period developed in Rome sometime between 1595 and 1625. It represented an anticlassical attitude and

included wild lighting effects, unconfined composition, and form which was free of symmetry coupled with highly turbulent emotionalism. The period symbolized in part a revolution against things intellectual in favor of a more tender treatment of man by viewing him in a more purely physical reality. The Baroque painters were greatly fascinated with light and often expressed a unique strength by altering spatial qualities and creating a most dramatic depiction of their subject. This period of strenuous upheavals of emotion lasted into the eighteenth century.

Baroque

Michelangelo Merisi da
 Caravaggio
Annibale Carracci
Pietro da Cortona
Giuseppi Maria Crespi
Carlo Dolci
Domenichino
Gaspard Dughet
Adam Elsheimer
Orazio Gentileschi
Luca Giordano
Lanfranco Giovanni
Giovanni Francesco
 Barbieri Guercino
Johann Liss
Claude Lorrain
Bartolommeo Manfredi
Carlo Maratta

Pierfrancesco Mola
Bartolome Esteban Murillo
Nicolas Poussin
Guido Reni
Jusepe de Ribera
Sebastiano Ricci
Salvator Rosa
Peter Paul Rubens
Andrea Sacchi
Giovanni Battista Salvi (II
 Sassoferrato)
Carlo Saraceni
Scarsellino
Francesco Solimena
Bernardo Strozzi
Trevisani
Jean de Boulogne Valentin

Seventeenth- and Nineteenth-Century Genre/ Landscape

Both the seventeenth century and the nineteenth century had a period in which the expression of art was devoted to the people (peasants, royalty, etc.) and their everyday rituals of life. There were picnics, grand parties, battle scenes, harbor views, landscapes, depictions of courtship and carousing, etc. Most of the aspects of daily life in the villages and cities were illustrated with colors which would reflect the mood of the era or situation. The works of the seventeenth century hark back to earlier times (the Renaissance, for example), whereas the nineteenth-century works are more reminiscent of the eighteenth century. Humanity and compassion were present in both centuries and appeared in the art of these times. Nature was also portrayed repeatedly in the fascination with storms, clouds, skies, and light in the seventeenth-century landscapes, and this influence carried over into the nineteenth century. Many of the seventeenth-century Dutch and Flemish landscape painters served as a great source of inspiration to the painters of the nineteenth century, who were somewhat less precise and more rounded in their techniques.

17th-Century Genre / Landscape / Still Life / Portrait

Hendrick Avercamp
Nicolaes Berchem
Job Berckheyde
Hans Bol
Ambrosius Bosschaert

Jan Both
Pieter Claesz
Albert Cuyp
Gerard David
Jacques de Gheyn

Jan van Goyen
Willem Claesz Heda
Jan Davidsz de Heem
Jan van der Heyden
Meindert Hobbema
Gillis d'Hondecoeter
Pieter de Hooch
Willem Kalf
Alexander Keirinck
Philips de Koninck
Pieter Molijn
Isaak van Ostade
Clara Peters

Frans Post
Paulus Potter
Rembrandt
Jacob van Ruisdael
Salomon van Ruysdael
Pieter Saenredam
Roelandt Savery
Hercules Seghers
Adriaen van de Velde
Esias van de Velde
Jan Vermeer
Cornelis Vroom
Philips Wouwermans

19th-Century genre/ Landscape/Still Life/ Portrait

Juaquin Sorolla y Bastida
Jean Béraud
Eugène de Blass
Giovanni Boldini
Antonio Brandeis
Pierre Puvis de Chavannes
Lucien Lévy-Dhurmer
Madrazo y Garreta
Victor Gilsoul
Ludwig Hartmann
Johan Jongkind
Hugo Kauffmann
Barend Koekkoek
Willem Koekkoek
Alfred Kowalski

Charles Henri Joseph
 Leickert
Baron Hendrik Ley
Leon Augustin Lhermitte
Max Liebermann
Federico Madrazo
Ernest Meissonier
Adolphe Monticelli
Gustave Moreau
David de Noter
Pieter Frans de Noter
Edward Portielje
René Princeteau
Jean Francois Raffaelli
Antonio Reyna

Reubens Santoro
Andreas Schelfhout
Adolf Schreyer
Cornel is Springer
Alfred Stevens
Fritz Thaulow

Franz Richard Unterberge
Jean Vibert
Giuseppe Pellizza da
 Volpedo
Ferdinand Waldmuller
Heinrich Zugel

Rococo

The Rococo Period in art history is basically confined to the eighteenth century in France. It describes an era of the simple aspects of court life, by depicting the exaggerated decorations of mankind. Highly detailed costumes and fancy decor emphasize the whimsical and the fantastic. Every concern is treated with a romance, a courtship, or a softening of a harsh reality. An attitude of love seems to have been injected into all situations to the extent that the subjects depicted are nearly drunk with sensitivity and compassion. There emerges an almost sugar-coated sense of reality with the fascination for manners and delicacy which leads ultimately to sentimental courtesies. Garb was illustrated in glowing color and was fanciful. Politeness, happiness, and total carefree Utopian spirit abounded everywhere.

Rococo

François Boucher
Antonio Canaletto
Jan Baptiste Chardin
François Hubert Drouais
Jean Honoré Fragonard

Thomas Gainsborough
Jean Baptiste Greuze
Francesco Guardi
Joseph Highmore
William Hogarth

Jean Antoine Houdon

Jan van Huysum

J. J. Kandler

Nicolas Lancret

Nicolas de Largilliere

François Lemoyne

Pietro Longhi

Meissen

L. G. Moreau

Charles Joseph Natoire

Jean Marc Nattier

Giovanni Paolo Pannini

J. B. F. Pater

Jean Baptist Perroneau

Giovanni Battista Piazzeta

Giambattista Piranesi

Jean Baptiste Le Prince

Joshua Reynolds

Hyacinthe Rigaud

Hubert Robert

Giovanni Batiste Tiepolo

Marie Vigée-Lebrun

Antoine Watteau

Francesco Zuccarelli

Neoclassic

The Neoclassic Period (1758–1844) in art is reminiscent of the Graeco-Roman classical period as would be any Neoclassic Period by definition. It represents somewhat of a throwback to the old traditions of the Classical Era, where importance is equated with literature and the human form. The center of this style of painting was in France where architectural precision became a preoccupation in painting. Aestheticism is the other component which typifies the Neoclassical style, and a great sense of achievement was found again through a rejuvenation of intellectual ideas.

The art of the period was formal and stiff compared to the frivolous spirit of the Rococo. Artists benefitted from the availability of academic training, the principles of which were to hark back to the Classical Era in art history.

Neoclassic

Pierre Jean David d'Angers
Pompeo Batoni
Louis Leopold Boilly
Giuseppe Cammarano
Antonio Canova
Jacques Louis David
John Flaxman
François Gérard
Francisco Goya

Jean Baptiste Greuze
Jean Antoine Houdon
Jean Auguste Dominique
 Ingres
Franz Krüger
Luigi Monfredini
Pierre-Paul Prud'hon
Joshua Reynolds
Johann Zoffany

Pre-Raphaelite and Victorian

The Pre-Raphaelite Brotherhood, active from about 1850 to 1860, was a group of painters who were violently opposed to the philosophies of the Royal Academy in England. Their goal was the return to the purity of art which existed prior to the High Renaissance. Their technique was one of exacting detail, to the point that they were compulsively precise; their colors were vibrant and their subjects conveyed a dreamlike nostalgia that looked back to the era before Raphael. Their vivid use of color and dignified depiction of the people yielded a medieval effect.

The Victorian age in painting illustrated a style of Realism which dwelled on themes like sin and formality. The message was one of the plight of the unfortunate, society's rejects. It was a time to reveal the moral atmosphere of the prim and the proper, the successful and the failed.

Pre-Raphaelite and Victorian

Lawrence Alma-Tadema

Richard Andsell

Alfred de Breanski

Henry Bright

Harry Brooker

Edward Coley Burne-Jones

Thomas Faed

Myles Birket Foster

William Powell Frith

William Godward

Atkinson Grimshaw

John Frederick Herring, Sr.

Arthur Hughes

William Holman Hunt

Edwin Henry Landseer

Lord Frederic Leighton

John Frederick Lewis

William McTaggart

George Bernard O'Neill

Henry Pether

Edward John Poynter

Richard Redgrave

Dante Gabriel Rossetti

John Byam Liston Shaw

Charles Sims

Simeon Solomon

Marcus Stone

John William Waterman

Frederick William Watts

Barbizon School

The Barbizon School is comprised of a specific group of landscape painters in France in the nineteenth century. The name "Barbizon" belongs to a town near Fontainebleau. The period actually began in the 1830s when it became somewhat intriguing yet not so fashionable to paint nature and things related to it. Favored subject matter included the wooded areas and forests as well as animals, especially cows grazing or sheep in their flock. The initial inspiration came from the English painters, notably the watercolorists who resided in or made visits to the area, but another influence was that of the seventeenth-century Dutch and Flemish landscape painters.

Peasant scenes were also a Barbizon subject matter, but the main thrust was toward nature and "Plein-Air" (open air or outdoor painting) with a heavy concentration on lakes, trees, rivers, and forests. Light and atmospheric effects were of utmost importance to the Barbizon painters, and were experimented with repeatedly in an attempt to create a new closeness to nature.

Barbizon (Main Group)

Jean Baptiste Camille Corot

Gustave Courbet

Charles Daubigny

Jules Dupré

Henri Joseph Harpignies

Charles Emile Jacque

François Millet

Diaz de la Pena

Théodore Rousseau

Constant Troyon

Additional Barbizon Painters

Karl Daubigny

Hippolyte Camille Delpy

Leon Richet

Paul Desire Trouillebert

IMPRESSIONISM

Impressionism is a term used to describe a technique in painting that employed the use of bright colors and dissolution of form to create an overall illusion. It stressed the loose rather than strictly realistic treatment of the subject. The way the subject was depicted invariably took precedence over the subject matter itself, because of the artist's fascination with the elements of light, purity of color, reflections, and strategically placed brush strokes. The final result was the creation of a less than accurate

rendition of the subject, but one that expressed the artist's own impression of what he perceived.

The Impressionist movement was centered in Paris in the 1860s and is generally considered to have lasted only into the 1880s, when new directions were taken by the artists of the period, though some still continued on in the true fashion of Impressionism, undaunted by the defection of their peers. As a result the date of transition is hard to pin down, because of the perpetuation by some artists of the Impressionistic style.

Impressionism

Eugène Boudin

Emile-Antoine Bourdelle

Mary Cassatt

Edgar Degas

Eugène Delacroix

Henri Fantin-Latour

Jean-Baptiste Armand
 Guillaumin

Johan Jongkind

Aristide Maillol

Édouard Manet

Claude Monet

Berthe Morisot

Camille Pissarro

Pierre Auguste Renoir

Auguste Rodin

Alfred Sisley

Henri de Toulouse-Lautrec

Louis Valtat

Postimpressionism (Expressionism, Abstraction)

In essence, Postimpressionism began in the 1880s when Impressionism began to go out of fashion. The Impressionist ideals, which overlooked reality of the subject matter in favor of the treatment of a purely visual effect, were now being cast aside, to be replaced by more serious respect for the subject. The viewer was to be given a more active

involvement in the work itself, no longer to be merely a spectator but rather an integral part of the painting. Nature continued to be important to these painters, but organization of theme through color, form, and brush technique worked harmoniously to achieve unification and coherence. Breaking down the theme into expression of stormy emotions through vigorous brushstroking and controlling the spatial arrangements yielded a sense of permanence, as opposed to the transitory, elusive qualities of Impressionism.

The Postimpressionism works achieved a greater depth of emotion, excitement, and strength than did those of the more effete Impressionist Era. Colors became bolder and more specific, and forms became more expressive. This age of painting lasted into the early twentieth century (1905–1906) at which point new directions of creation were taken.

Postimpressionism/Expressionism

Charles Angrand
Emile Bernard
Pierre Bonnard
Georges Braque
Eugène Carrière
Henri Edmund Cross
Andre Derain
Raoul Dufy
Paul Gauguin
Vincent van Gogh
Marie Laurencin
Albert Lebourg
Stanislas Lépine
Maximilien Luce
Aristide Maillol
Albert Marquet
Henri Martin
Henri Matisse
Amedeo Modigliani
Henry Moret
Edvard Munch
Pablo Picasso
Odilon Redon
Georges Rouault
Paul Sérusier
Georges Seurat

Henri Le Sidaner	Maurice Utrillo
Paul Signac	Maurice de Vlaminck
Chaim Soutine	Édouard Vuillard

Modern (Fauvism, Cubism, Futurism, Surrealism)

The influence of the Postimpressionists led to the birth of Fauvism, a school of painting in which the artists used an expressionistic method of coloration. Their tones were of extraordinary vibrance and excessive brilliance. Frequently, there was distortion of accuracy by means of wild exaggeration of the colors. The themes used a predominance of vigorous reds, oranges, yellows, blues, purples, and greens. Subjects consisted of landscapes, seascapes, river views, and even portraiture. To see a Fauve painting is to experience exhilaration, to thrill to a glimpse of refreshment, and to smile at the daring power of the well-constructed composition. The reign of the Fauvist Period was from the very early 1900s to about 1910, after which the strength became somewhat muted into a more mannered, weak style.

Cubism, by definition, is a style of painting in which the theme is expressed in form by combinations of geometric shapes. The angular configurations, when perceived as a single, interrelated unit, yield a mechanical but organized subject matter. Often the background is merged comfortably with the subject, as if the two were designed to flow together.

Other facets of Cubism provide a kaleidoscopic compositional effect where the subject and background are made to appear as very distinct geometric entities, so that the viewer could see the overall theme from a variety of viewpoints. Cubism for the most part thrived in the early

1900s and remained popular until the teens, but the technique was still practiced in later years.

Futurism was a movement that started in Italy in the first decade of the twentieth century. It turned away from the past for its ideals and aimed directly at the future. The works depicted elements in motion—employing trains, cars, and figures—to illustrate the strength of the artists' feelings. Everything moved in a very dynamic, brisk fashion. Color was a significant element, used in conjunction with geometric precision.

Surrealism is a school of painting and sculpture in the modem category, and it takes its name from a style that employs a highly realistic treatment of the subject and its corresponding space. It portrays its subject in so real a fashion that it almost becomes unreal. It has a dreamlike quality that is in a sense superconscious and futuristic at the same time. The Surrealists present a sense of simplicity, but are actually extremely precise and complex in their technique. They are both amusing and accurate in their symbolic expression of man and his subconscious.

Fauvism

André Derain
Raoul Dufy
Othon Friesz
Henri Manguin

Albert Marquet
Henri Matisse
Georges Rouault

Cubism

(This list also includes artists of the Abstract and Constructivist schools)

Alexander Archipenko
Georges Braque
Le Courbusier (Charles
 Édouard Jeanneret)
Robert Delaunay
Theo van Doesburg
Marcel Duchamp
Lyonel Feininger
Roger de Ia Fresnaye
Albert Gleizes
Juan Gris
Alexej Jawlensky
Wassily Kandinsky

Paul Klee
Fernand Léger
Jean Lunçat
Auguste Macke
André Masson
Roberto Echaurren Matta
Piet Mondrian
Francis Picabia
Pablo Picasso
Maris Sironi
Georges Valmier
Jacques Villon
Ossip Zadkine

Futurism

Giacomo Balla
Umberto Boccioni
Marcel Duchamp

Luigi Russolo
Gino Severini
Leopold Survage

Surrealism

Carlo Carra
Marc Chagall
Giorgio de Chirico
Salvador Dali
Paul Delvaux
Max Ernst
Ferdinand Hodler

René Magritte
André Masson
Joan Miró
Giorgio Morandi
Odilon Redon
Graham Sutherland
Yves Tanguy

AMERICAN
Colonial

The artists of the Colonial era in American history were primarily portrait painters, though some did landscapes and battle scenes. Their technique exhibited an unrefined nature, although seldom was the style any less than extremely skillful and competently engineered. Perspective was accurate, and close attention was given to detail and color, which expressively and exactly related the subjects and their garb.

These artists were mostly influenced by the English portrait painters, but the American works were somewhat less decorative than those of the English and appeared to convey an overwhelming sense of power as well. Perhaps the greatest creative asset, which is characteristic of the work of this period, is the psychological expression and emotional revelation of the subject.

Colonial

Washington Allston	Samuel Morse
Joseph Blackburn	John Neagle
John Singleton Copley	Charles Willson Peale
Ralph Earl	James Peale
Jacob Eichholtz	Rembrandt Peale
Robert Feke	John Smibert
William Groombridge	Gilbert Stuart
Gustavus Hesselius	Thomas Sully
John Hesselius	Jeremiah Theus
Henry Inman	John Vanderlyn
John Wesley Jarvis	Benjamin West

John Wollaston Joseph Wright

Primitive Painting

Primitive is the name given to a type of painting that flourished in the first seventy-five years of the nineteenth century. Its style was quite different from the academic traditions with which we are so familiar. For the most part, these artists weren't influenced by any predecessors; they were largely unschooled and untrained, and for many years their work was frowned upon and even loathed by the critics, who explained that they were stiff, crude, and of very poor quality. Today, of course, that attitude is considered to be one of ignorance, for the genius and skill of these artists is easily recognizable in their abstract technique. It is not abstract in the sense that forms are indistinguishable, but rather in the lack of perspective and visual unification of the subject matter.

Quaintness and charm are exuded from fine primitive (also called naive) paintings, but they also show a very powerful sense of creativity, which is the essence of the quality that underscores their appeal.

Primitive

Ruth Henshaw Bascom Rufus Hathaway
Franz Beck Edward Hicks
Zedekiah Belknap William Jennys
John Bradley Joshua Johnston
Thomas Chambers John Kane
James Evans Frederick Kemmelmeyer
Erastus Salisbury Field Nathaniel Mayhew

Anna Mary Robertson
 Moses (Grandma Moses)
Ammi Phillips
Joseph Pickett

Horace Pippin
Matthew Prior
Joseph Storck

Genre Realism

The painters who fall into this category were working throughout the nineteenth century. Their approach to subject matter was one of direct realism. Their treatment was more tender than photographic, but was nevertheless very bold in color, and light played an important role in the development of this style, which focused on views of daily life as well as portraits. Rural scenes were popular as were political commentaries, sporting views, and hunting subjects, and it was the subject that weighed most heavily in the minds of these painters. The very technique that they pursued to reveal their subject evolved as a result of their efforts for an accurate portrayal. They were inspired by the pioneer spirit of America, the raw new growth of our country, and reflected this through a fresh interpretation by use of dramatic color and faithful emotional translation. These painters of Realistic Genre were indisputably the most powerful and emotionally communicative of any in our history. They were masters in their representation of frontier life in America.

Genre / Realism

Thomas Anschutz
George Caleb Bingham

David Gilmour Blythe
John George Brown

Thomas Eakins
Francis Edmonds
Edward Lamson Henry
Winslow Homer
Eastman Johnson

William Sidney Mount
Thomas Nast
William Winner
Thomas Waterman Wood

Still Life

Still Life painting has held the fascination of American artists since the eighteenth century. It began with the Peale tradition and transformed itself many times through the various phases of fruit, flowers, game, and trompe l'oeil. The techniques that were used in these Still Life works ran the gamut from Primitive to Realistic Precisionism, touching styles like Impressionism and Romanticism, with influences by the Pre-Raphaelites and the Visionaries of the latter part of the nineteenth century.

Subjects changed as various elements went out of fashion (the peach, for example, was replaced with other fruits). Tabletop Still Life works began to illustrate everything from vases and urns to guns, violins, newspapers, barrels, and flowers, with the inclusion of magnificent foliage. These painters of Still Life subjects were fascinated with the beauty of nature's bounty and concentrated on fruits and flowers themselves, rather than on the landscape in which these things flourished.

Still Life

John Chalfant
George Cope
Joseph Decker

Victor Dubreuil
Robert Spear Dunning
John Francis

John Haberle

William Harnett

Martin Johnson Heade

Albert King

Paul Lacroix

William J. McClosky

George Ord

James Peale

Raphaelle Peale

John Frederick Peto

Alexander Pope

Milne Ramsey

Severin Roesen

Andrew John Henry Way

Western

One of the most exciting aspects of painting in American history is the Western School. From the mid-1800s to the present day there have been and still are numerous paint-ers west of the Mississippi producing their renditions of frontier life. The most typical subjects were the American cowboy and the American Indian. They have tradition-ally been depicted embroiled in battle, warring over land, food, and civil rights. Gunfighters, soldiers, Indian scouts and chiefs are variously illustrated in their daily rituals as well as in direct conflict with one another. The technique through which these scenes are painted is one of Realism though some artists slipped into an Impressionistic style. Colors were vibrant and boldly applied, and strict attention was paid to detail that would identify characteristics of a particular Indian tribe or a cavalry regiment. Whether the subject was, or had as a background, the desert land of the Southwest, the wild waters of the Colorado River, the sober-ing peaks and gorges of the untamed Rocky Mountains, or a fiery sunset over the campfire at day's end, the underlying message was always one which unveiled the character of the old West—its pride, its energy, and its ruggedness.

Western

Oscar Berninghaus	William Robinson Leigh
Albert Bierstadt	Herman Atkins MacNeil
Ralph Blakelock	Alfred Jacob Miller
Ernest Blumenschein	Thomas Moran
Karl Bodmer	Bert Phillips
Edward Borein	Alexander Phimister
Carl Oscar Borg	Proctor
George de Forest Brush	William Ranney
Thomas Mickell Burnham	Frederic Remington
William Cary	Charles Russell
George Catlin	Charles Schreyvogel
Irving Couse	Julian Scott
Cyrus Dallin	Olaf Seltzer
Maynard Dixon	Joseph Sharp
Nicolai Fechin	John Mix Stanley
Leon Gaspard	Olaf Wieghorst
William Victor Higgins	Frank Reed Whiteside
Frank Tenney Johnson	

Hudson River School

The group of artists who are associated with this school fall into a broad classification of romantic landscape painting.

The lure was one of nature: oceans, rivers (notably but not limited to the Hudson), woods, dense forests, and mountains, with a strong concern for atmospheric representation. There was a special fascination for the effect of light in conjunction with a variety of colors, which ranged from the somber to the vibrant, but nothing was

intended to be anything less than a direct detailed portrayal of nature itself, with the application of intense clarity and linear precision. Whether the subject included wild animals or figures, took place along the Hudson, by the White Mountains, along the coast of Maine, or in the mountainous West, the preoccupation was always with the untamed vast wilderness of America. The dates of this school of painting go back to the early 1820s and stretch as late as the 1890s. The School of Luminism actually falls under the broad umbrella of the Hudson River School and in oversimplified terms is merely the period when light and clarity expressly take priority over the other characteristics of this school.

Hudson River (and Luminist)

Washington Allston
William Henry Bartlett
Albert Bierstadt
William Bradford
Alfred T. Bricher
John Casilear
Frederic Church
Thomas Cole
Samuel Colman
Jasper Cropsey
Thomas Doughty
Asher B. Durand
Sanford Gifford
James Hart
William Hart

William Stanley Haseltine
Martin Johnson Heade
David Johnson
John Frederick Kensett
Fitz Hugh Lane
William Trost Richards
Francis Silva
James Smillie
William Sonntag
James A. Suydam
William Guy Wall
Robert Weir
T. Worthington
 Whittredge

American Barbizon

In the late nineteenth century, some years after Luminism and after the onset of Impressionism, there existed a group of American painters who were working in the French Barbizon style. They focused on the accurate representation of nature and its elements and were fascinated by the atmospheric effects of sunlight, cloud, and storm. As with the French painters, they attempted to achieve precision of detail without distorting the reality of their subject, but their primary concern was for a romantic portrayal of the landscape itself with the accentuation of figures and animals being of secondary importance. Some of the Barbizon artists occasionally made departures into an Impressionistic mode, and while their style of painting changed its design, the theme remained close to nature. Light was a major influence throughout the landscapes of these painters, and they remained loyal to the notion of the Plein Air school which was created in France.

Barbizon

George Inness

Hugh Bolton Jones

William Keith

Homer Dodge Martin

J. Francis Murphy

Julian Onderdonk

Henry Ward Ranger

Alexander Wyant

Impressionism

American painters of the late nineteenth-century school of Impressionism, though inspired by the French Impressionists, had a more clearly defined style that differed considerably from their counterparts. It embraced a

wealth of rich saturated colors and a strong reluctance to dissolve the solidarity of form into diffused areas of fragmented color. The subject was always of primary importance, not the treatment of light and color—the main concern of the French Impressionists. The effect of the American technique was one of beauty and elegance, but one which to some degree lacked the softness and tenderness of the French paintings. The American paintings did not exhibit the same opulent colorism as the French paintings, but did possess an atmospheric quality which worked as a perfect complement to its well-organized composition.

American Impressionism should also be noted for its individuality and boldness; it should not be considered an attempt at reproducing the characteristics of French painting of the late nineteenth century.

Impressionism

George Bellows
Frank Benson
Theodore Butler
Emil Carisen
Mary Cassatt
William Merritt Chase
Charles Curran
Thomas Wilmer Dewing
Frank Duveneck
John Enneking
Carl Frederick Frieseke
Daniel Garber
Arthur C. Goodwin

Phillip Hale
Frederick Childe Hassam
Thomas Hovenden
Ernest Lawson
Willard Metcalf
Richard E. Miller
Edward Potthast
Edward Redfield
Robert Reid
Theodore Robinson
John Singer Sargent
George Gardner Symons
Edmund Tarbell

Abbott Thayer

John Henry Twachtman

Robert Vonnoh

Martha Walter

J. Alden Weir

James Abbott McNeill
Whistler

The Eight

The painters known as The Eight, or the Ashcan School were basically realistic in technique. Their place in time is very early twentieth century, and the center of their activity was first in Philadelphia, and later in New York, though there were many excursions to the West and other parts of the country. The name derives from the fact that they were eight artists whose work dwelled on the everyday aspects of life. Their subjects consisted of rugged street scenes, often with a hint of industrial progress, burlesque houses, bars, and even street urchins. The truths that were exposed by the work of these painters were rejected and condemned by the public, but they were accurate depictions which couldn't be denied. Color tonalities were drab and without excitement, and they too reflected the mood of squalor, unrest, and depression. This era was convincingly illustrated through the art of its time, and it will remain an important period in our history, made immortal by these eight painters.

Ashcan (The Eight)

Arthur B. Davies

William Glackens

Robert Henri

Ernest Lawson

George Luks

Maurice Prendergast

Everett Shinn

John Sloan

Early Twentieth-Century Realism, Abstraction, and Cubism

The early years of the twentieth century saw a variety of experimental searches for new directions in art. There was born a new Realism, which evolved from the earlier achievements of Eakins and Anschutz—colors more vibrant and images more sharply defined, nearly to the point of appearing architectural. The subject matter focused on industry, rural life, and the sea. The effect was the creation of a more contemporary revamped Realism.

Cubism and Abstraction also had their period of appreciation. Experimentation with form by systematic dissolution and mechanical reorientation was an intriguing practice that reflected some of the influence of the European Cubist painters, yet it retained a distinct American identity by departing from earthen colors to the use of vivid bright colors and hues to express its message. With the work of some, the subject and the background were harmonious in texture, in contrast to the European Cubists who separated the planes of the subject from those of the external components which surrounded it.

Early 20th-Century Realism /Abstraction / Cubism

Milton Avery	Charles Demuth
George Bellows	Preston Dickenson
Charles Burchfield	Arthur Dove
Arthur B. Carles	Guy Pene Du Bois
Stuart Davis	Lyonel Feininger

Morris Graves
William Gropper
Marsden Hartley
Edward Hopper
Rockwell Kent
Karl Knaths
Walt Kuhn
John Marin
Reginald Marsh
Alfred Maurer
Jerome Myers
Georgia O'Keeffe

Norman Rockwell
Morgan Russell
Morton Schamberg
Ben Shahn
Charles Sheeler
Niles Spencer
Joseph Stella
Alice Kent Stoddard
Franklin Watkins
Max Weber
Stanton MacDonald
 Wright

Regionalism

In the 1920s the school of painting known as Regionalism was formed. It consisted of only a handful of painters who decided that America, rather than Europe, was then the place to find new discovery and interest in painting. New events were taking place daily in an atmosphere that culminated in the Great Depression, and these painters later found renewed inspiration in the New Deal policies of Roosevelt. The subjects of primary interest were agricultural and industrial. There were paintings of rice fields, farms, cotton pickers, empty country roads, corn harvests, train derailments, Negro soldiers, bootleggers, the gathering of wheat, sorting of tobacco, and haying. Most of the subject matter emphasized and recounted the sleepy rural life-style of the American Midwest. It was portrayed in a Mannerist technique that made

it evident that this facet of a grass-roots America was out of synchronization with the industrial sophistication of the East. Colors were lively, and the medium of tempera was commonly used; it seemed to help convey a sense of timelessness—a standstill phenomenon which expressed the isolation of Midwest areas such as Missouri, Iowa, Nebraska, Texas, Kansas, and Indiana.

Regionalism

Thomas Hart Benton	Reginald Marsh
Charles Burchfield	Grant Wood
John Steuart Curry	

Twentieth-Century Naturalism

This is a category into which I place the painters (some of whom remain active today) of landscapes, genre scenes, and portraits, who use a technique that is steeped in Realism but who go one step further by creating an effect of Naturalism. That is, in conjunction with the lifelike attraction which is produced by the realistic treatment of the subject, there is an additional push toward softness and accuracy in the adaptation of very earthen color tones. The style frequently embraces the use of tempera, which creates a flatness that subsequently draws the viewer into the work and evokes a strong feeling of one's own presence in the painting. This effect is different from any inspired by the more traditional forms of Realism because of a super-crisp focus of the subject, which provides for a unique quality reminiscent of the twilight stage between sleep and consciousness. The result is the fabrication of

a dreamlike appearance which approaches a mood of Surrealism.

20th-Century Naturalism

Peter Blume	Andrew Wyeth
Maxfield Parrish	Jamie Wyeth

Post-War, Pop Art & Contemporary

In this day and age we must include a group of artists from the Post-War era (after 1945) through Modern day. There are too many to list in their entirety but below are noted several as a cross-section of the most desirable and interesting in my opinion. These are artists who have gone to the next step in their compositions as they tell their story, one image at a time. Snapshot reflections of their life or of societal happenings. A wide spread of time from 1945–2015 with so many changes, both for the better and not, giving fodder to the art world creators and collectors. There are countless more who would fit well on the list but it would be next to impossible to include them all.

Abstraction is still very much in vogue, albeit a very distinct variant from those of the earlier French painters who took Cubism and went to the next step. The Modern abstractionists invoked Expressionism and infused their own dissolution of form utilizing layers of subject matter creating a multidimensional vision for their viewers. Color, line, spatial reference, scale, motion and vibration are all factors that work in a very synchronous partnership, coming together as one.

The nationalities are all encompassing; American, Latin American, South American, European, Asian, etc. There are no borders; art is art, no matter the origin. The inspiration, if it is there, will be everywhere and anywhere. The media are as diverse as the range of subjects. Oil paintings, acrylic works, sculpture, paper constructions, metal works, plexiglass creations, colored light displays, slide shows, photographs, videos and just about anything else from which one can create a work of art.

Post-War, Pop Art & Contemporary

Mark Rothko	David Park
Francis Bacon	Robert Rauschenberg
Milton Avery	Edward Ruscha
Hans Hoffman	Jackson Pollock
Willem de Kooning	Paul Rusconi
Gerhard Richter	Clyfford Still
Andy Warhol	Wayne Thiebaud
Richard Diebenkorn	Cy Twombly
Adolph Gottlieb	Joseph Albers
Cleve Gray	Tom Wesselmann
David Hockney	Theodoros Stamos
James Rosenquist	Nicolas de Stael
Robert Indiana	Graham Sutherland
Roy Lichtenstein	Richard Serra
Morris Louis	Egon Schiele
Robert Motherwell	Claes Oldenburg
Boris Lurie	Carlos Merida
Sidney Gross	Helen Frankenthaler
Bruce Nauman	Agnes Martin

Jasper Johns
Jeff Koons
Larry Poons
Donald Judd
Arshile Gorky
Jim Dine
Sam Francis
Lucien Freud

Sol LeWitt
Alexander Calder
John Chamberlain
Michael Goldberg
Lee Krasner
Joan Mitchell
Amalie Rothschild
Barnett Newman

Chapter 13
Recommended Galleries

CALIFORNIA

LOS ANGELES
Dalzell Hatfield Galleries
De Ville Galleries
Goldfield Galleries
Petersen Galleries
Terry De Lapp Gallery

SAN FRANCISCO
Hunter Gallery
Maxwell Galleries, Ltd.
Wortsman-Stewart Galleries, Inc.

CONNECTICUT

LITCHFIELD
Tillou Gallery, Inc.

FLORIDA

MIAMI
Frederick Mueller Art Gallery

ILLINOIS

CHICAGO
R. H. Love Galleries, Inc.
Maurice Sternberg Galleries

MASSACHUSETTS

BOSTON
Childs Gallery
Vose Galleries of Boston, Inc.

HINGHAM
Pierce Galleries, Inc.

SALEM
Marine Arts Gallery

NEW JERSEY

ESSEX FELLS
Henry B. Holt

NEW MEXICO

SANTA FE
Fenn Galleries, Ltd.
The Peters Corporation

NEW YORK

BUFFALO
Dana E. Tillou Gallery

NEW YORK
ACA Galleries
Acquavella Art Galleries, Inc.
Allan Stone Gallery

Andrew Crispo Gallery, Inc.
Andre Emmerich Gallery
Babcock Galleries
J. N. Bartfield Art Galleries
Bernard Levy & S. Dean, Inc.
Berry-Hill Galleries, Inc.
Central Picture Galleries
Chapellier Galleries, Inc.
Coe-Kerr Gallery
Cordier & Ekstrom, Inc.
David Tunick, Inc.
Davis & Long Company
E. V. Thaw & Co.
FAR Gallery
Findlay Galleries
Forum Gallery
Galerie St. Erienne
Gertrude Stein Gallery
Gimpel & Weitzenhoffer Ltd.
Graham Gallery
Grand Central Art Galleries, Inc.
Hammer Galleries Inc.
H. Roman Inc.
Hirschl & Adler Galleries, Inc.
H. Shickman Gallery
James Goodman Gallery
James Maroney, Inc.
Joan Michelman, Ltd.
Jordan Volpe Gallery
Kennedy Galleries, Inc.
M. Knoedler & Co. Inc.
Kraushaar Galleries
Leo Castelli Gallery
Leonard Hutton
Lucien Goldschmidt, Inc.
Marbella Gallery
Marlborough Gallery
Martha Jackson Gallery
Nancy Hoffman Gallery Inc.
Newhouse Galleries, Inc.
Pace Gallery & Editions
Paul Rosenberg & Co.
Perls Galleries
Pierre Matisse Gallery

Richard L. Feigen & Co.
Rosenberg & Stiebel, Inc.
Salander O'Reilly Galleries, Inc.
Robert Schoelkopf Gallery
Schweitzer Gallery
Serge Sabarsky Gallery, Inc.
Shepherd Gallery
Sid Deutsch Art Gallery
Sidney Janis Gallery
Ira Spanierman Gallery
Spencer A. Samuels & Co. Ltd.
Staempfli Gallery, Inc.
Terry Dintenfass, Inc.
Thomas Colville
Tibor DeNagy Art Gallery
Washburn Gallery Inc.
Wildenstein & Co. Inc.
William Edward O'Reilly, Inc.
Zabriskie Gallery

NORTH CAROLINA

RALEIGH
Craig & Tarlton, Inc.

PENNSYLVANIA

PHILADELPHIA
David David Art Gallery
Gross-McCleaf Gallery
Janet Fleisher Gallery
Makler Gallery
Marian Locks Gallery
Newman Galleries

TENNESSEE

LOOKOUT MOUNTAIN
Frank E. Fowler

TEXAS

FORT WORTH
The Hall Gallery

HOUSTON
Hooks-Epstein Gallery
Meredith Long Galleries
Robert-Rice Gallery, Inc.

DALLAS
Altermann Art Gallery

VIRGINIA

MIDDLEBURG
The Sporting Gallery, Inc.

WASHINGTON, D.C.
Adams Davidson Galleries

Chapter 13
Recommended Museums

CALIFORNIA

LOS ANGELES
Los Angeles County Museum of Art

MALIBU
J. Paul Getty Museum

SACRAMENTO
E. B. Crocker Art Gallery

SAN DIEGO
Timken Art Gallery

SAN FRANCISCO
M. H. De Young Memorial
Museum
California Palace of the Legion of
Honor

SANTA BARBARA
The Santa Barbara Museum of Art

COLORADO

DENVER
The Denver Art Museum

CONNECTICUT

HARTFORD
Wadsworth Atheneum

NEW HAVEN
Yale University Gallery of Fine Arts

DELAWARE

WINTERTHUR
Henry Francis DuPont Winterthur
Museum

FLORIDA

JACKSONVILLE
Cummer Gallery of Art

ST. PETERSBURG
Museum of Fine Arts of St.
Petersburg

SARASOTA
John and Mable Ringling Museum
of Art

GEORGIA

ATHENS
Georgia Museum of Art, University
of Georgia

COLUMBUS
Columbus Museum of Arts and
Sciences Inc.

ILLINOIS

CHICAGO
The Art Institute of Chicago

KANSAS

LAWRENCE
Helen Foresman Spencer
Museum of Art

KENTUCKY

LOUISVILLE
J. B. Speed Memorial Museum

LOUISIANA

NEW ORLEANS
New Orleans Museum of Art

MARYLAND

BALTIMORE
The Baltimore Museum of Art

MASSACHUSETTS

BOSTON
Museum of Fine Arts

CAMBRIDGE
Fogg Art Museum

SALEM
Peabody Museum of Salem

MICHIGAN

DETROIT
The Detroit Institute of Arts

MINNESOTA

MINNEAPOLIS
The Minneapolis Institute of Arts

MISSOURI

KANSAS CITY
William Rockhill Nelson Gallery of
Art and Mary Atkins Museum of
Fine Arts

ST. LOUIS
The St. Louis Art Museum

NEBRASKA

OMAHA
Joslyn Art Museum

NEW JERSEY

PRINCETON
The Art Museum, Princeton
University

NEW YORK

BROOKLYN
The Brooklyn Museum

MANHATTAN
The Frick Collection
The Solomon R. Guggenheim
Museum
The Metropolitan Museum of Art
The Museum of Modern Art
Whitney Museum of American Art

OHIO

CINCINNATI
Cincinnati Art Museum

CLEVELAND
Cleveland Museum of Art

DAYTON
Dayton Art Institute

TOLEDO
The Toledo Museum of Art

OKLAHOMA

OKLAHOMA CITY
National Cowboy Hall of Fame and Western Heritage Center

TULSA
Thomas Gilcrease Institute of American History and Art

OREGON

PORTLAND
Portland Art Museum

PENNSYLVANIA

PHILADELPHIA
Pennsylvania Academy of Fine Arts
Philadelphia Maritime Museum
Philadelphia Museum of Art

PITTSBURGH
Museum of Art, Carnegie Institute

RHODE ISLAND

PROVIDENCE
Museum of Art, Rhode Island School of Design

TEXAS

EL PASO
El Paso Museum of Art

FORT WORTH
Amon Carter Museum of Western Art
Kimball Art Museum

HOUSTON
The Museum of Fine Arts

UTAH

PROVO
Brigham Young University Fine Arts Collection

SALT LAKE CITY
Utah Museum of Fine Arts

VIRGINIA

RICHMOND
Virginia Museum of Fine Arts

WILLIAMSBURG
Abby Aldrich Rockefeller Folk Art Collection

WASHINGTON

SEATTLE
Seattle Art Museum

WASHINGTON, D.C.
Corcoran Gallery of Art Hirshhorn Museum and Sculpture Garden
National Collection of Fine Arts
National Gallery of Art
National Portrait Gallery

WISCONSIN

MADISON
Elvehjem Art Center

WYOMING

CODY
Buffalo Bill Historical Center

Index